Joel Shapiro: Sculpture in Clay, Plaster, Wood, Iron, and Bronze, 1971-1997

September 20, 1997 through January 4, 1998
ADDISON GALLERY OF AMERICAN ART
Phillips Academy
Andover, Massachusetts

Joel Shapiro: Sculpture in Clay, Plaster, Wood, Iron, and Bronze, 1971-1997

ADDISON GALLERY OF AMERICAN ART, ANDOVER, MASSACHUSETTS

September 20, 1997 through January 4, 1998

The exhibition, artist-in-residency, and publication *Joel Shapiro: Sculpture in Clay, Plaster, Wood, Iron, and Bronze, 1971-1997* have been generously funded by Ed and Susie Elson and the Elson Artist-in-Residence Fund.

Jock Reynolds, curator

Published by the Addison Gallery of American Art, Phillips Academy, Andover, Massachusetts.

Design by Ellen Hardy
Production assistance by Maureen Chase
Printing by LaVigne Inc.

ISBN 1-879886-44-8
Library of Congress Catalog Card Number: 98-073852

Cover, flyleaf, and image at right: View in Joel Shapiro's studio, New York, spring 1997.
Back cover and back flyleaf: View in Joel Shapiro's studio, New York, spring 1998.

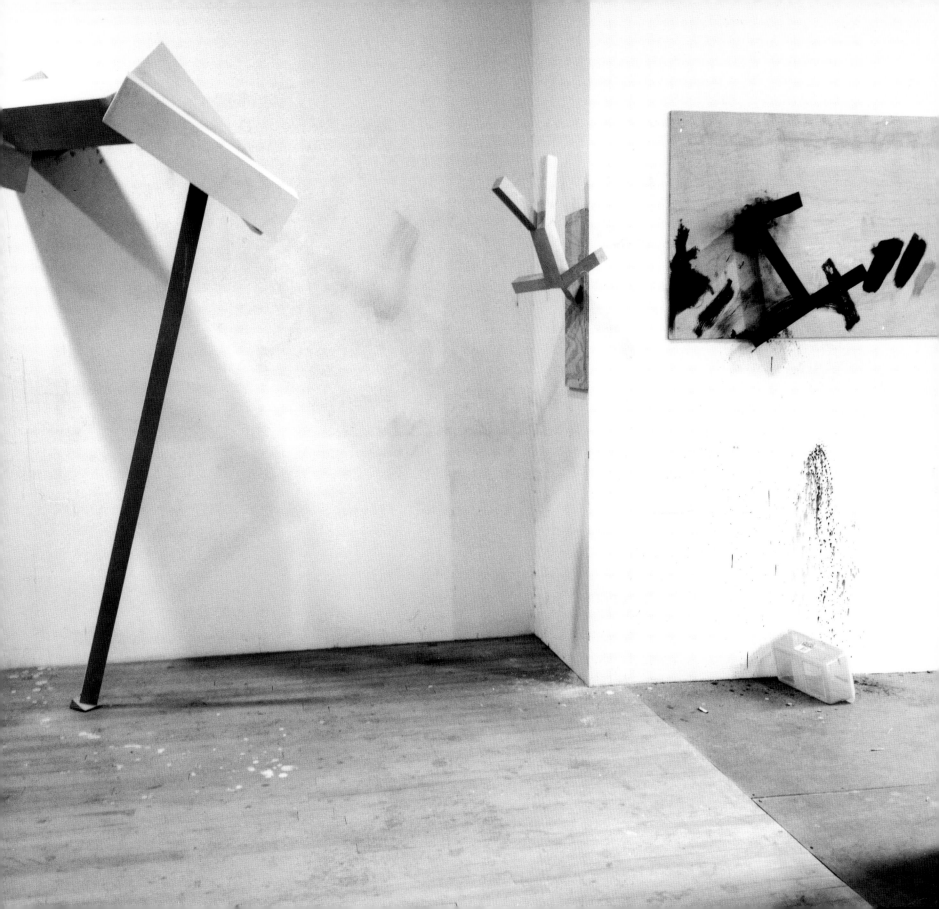

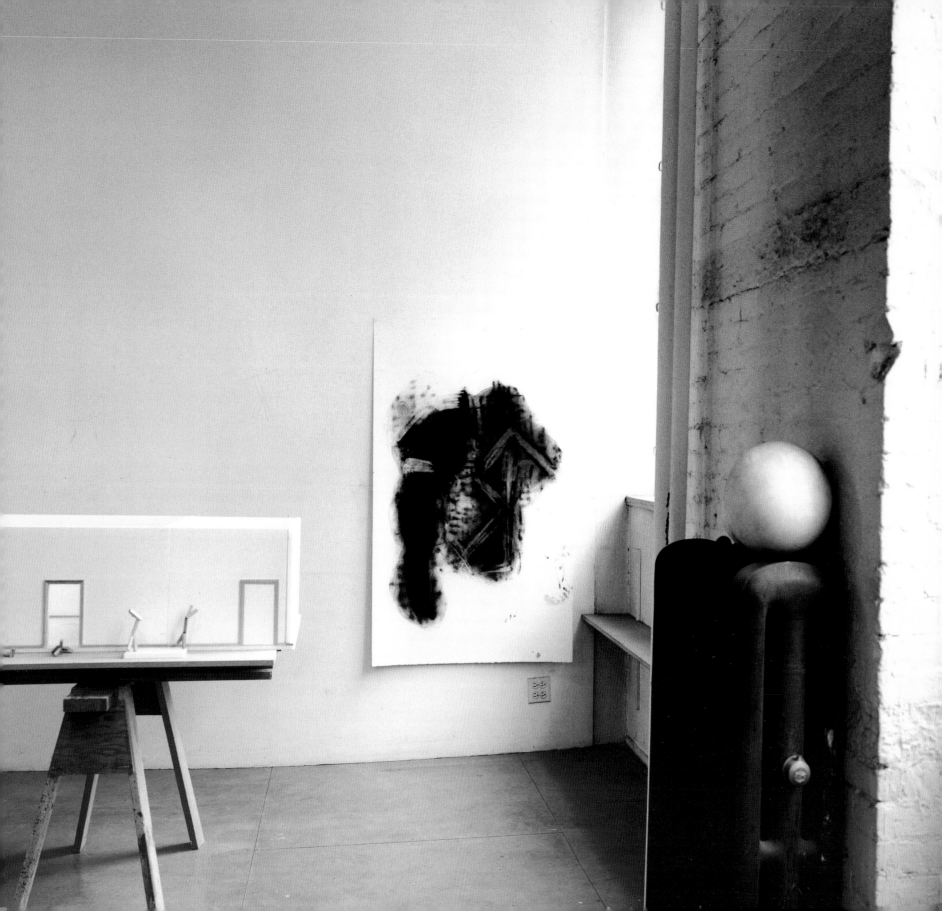

Introduction

THIS PUBLICATION DOCUMENTS AN exhibition and artist-in-residence project that enabled Joel Shapiro to survey a quarter century of his sculptural production, create new work, and meet with students and teachers interested in his art and ideas.

The particular selection of sculpture and the form chosen for this exhibition arose from a series of conversations and studio visits I conducted with Shapiro in New York during the winter, spring, and summer of 1997. The artist generously allowed me access to his studio and storage spaces, where I freely studied and photographed a significant body of work he has retained for himself and his family. Surveying the diverse body of sculpture Shapiro has produced in media including clay, plaster, wood, iron, and bronze, he and I also discussed the many ways his works have been installed, viewed, and interpreted within public exhibitions and architectural spaces. From our conversations arose the idea to structure the Addison exhibition as a two-phase installation of sculpture which we would initially contextualize and alter on-site at the Gallery from a master list of pre-selected sculptures and later augment with new sculptures

Shapiro would fabricate in residence. We wanted the two-phase installation to present a wide array of Shapiro's early works in dialogue with one another, creating an open-ended visual narrative that the artist could then stir up with some recent and very contemporary responses to his past creations.

With all of this in mind, we shipped a truckload of work to Andover, from which we selected the sculptures for the first installation. The artist and our museum staff installed these works in five of the Addison's galleries. After his exhibition opened in September 1997, Shapiro remained on campus to create new works in the Addison's visiting-artist studio and to host classes of students who came to talk about what he was showing and making. Simultaneously, Shapiro grappled with installing another ambitious exhibition of his work, grouping some of his recent bronze figures in an installation that was presented at the Haus der Kunst in Munich, Germany. By early November, when the second phase of Shapiro's Addison exhibition was selected and installed, the artist chose to introduce some new painted wooden figures, mounting some of them directly on the walls of the museum. He continued to meet with students and delivered two public lectures, one at the Addison and the other at Harvard University's

w in Joel Shapiro's
dio, New York.

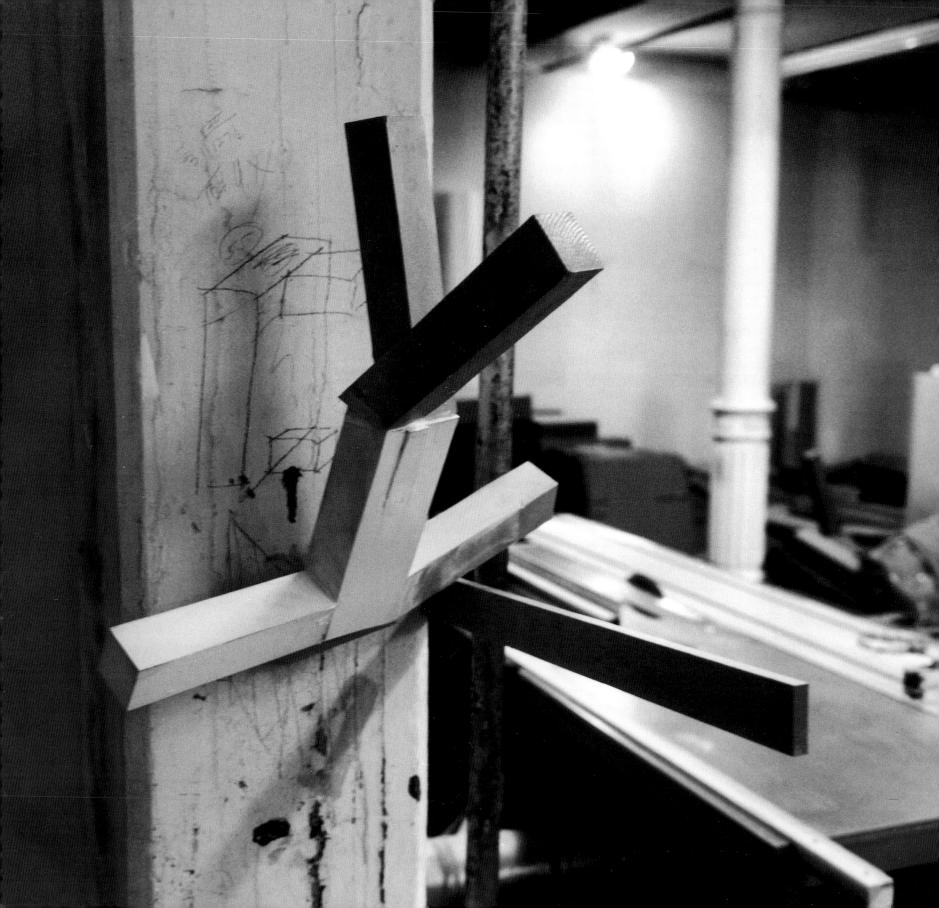

Carpenter Center for the Visual Arts. The Harvard talk was edited for publication in this catalogue.

When the entire exhibition and residency project concluded in January 1998, Shapiro and I continued our studio conversations in New York, wanting to somehow measure the sustained effect the artist's working stay in Andover was exerting on his new work—thus arose our illustrated interview.

The entire exhibition and residency project were charged with creative reflection and ferment, and throughout Joel Shapiro engaged this teaching museum, its staff and audiences with great energy and focus. We are especially grateful to him for sharing his art, ideas, and time so freely with the Addison and its surrounding learning communities. In thanking Shapiro for the opportunity to publicly present and support his work, we would also like to thank a number of other individuals who helped bring this project to fruition.

We are especially grateful to Edward and Susie Elson, great benefactors of the arts at Phillips Academy, for providing a major gift to underwrite Joel Shapiro's exhibition and this catalogue. Their generosity has kindly supplemented the endowed fund that supported Shapiro's residency and earlier established the Addison's Elson Artist-in-Residence program. The Gallery's staff, as always, gave its all in realizing this project, with Juli McDonough, our curatorial assistant, providing extended help to me and Shapiro throughout this year in the organization of our work. From Shapiro's studio staff, we wish to thank Pamela Franks and Lindsay Walt, who attended to a myriad of organizational details with great efficiency and good cheer. Ms. Franks also edited the Harvard lecture for publication. At Harvard University's Carpenter Center for the Visual Arts and Art Museums, we wish to thank our colleagues, Ellen Phelan, Chris Killip, and James Cuno, all of whom kindly hosted our guest artist for his Cambridge presentation and meetings with students. Thanks are also due Paula Cooper of the Paula Cooper Gallery, New York and Douglas Baxter of PaceWildenstein New York for their kind assistance along the way. We are indebted to Ellen Hardy for another fine job in designing this publication, and to Greg Heins and Leslie Maloney, who contributed photographs to document Shapiro's exhibition and residency.

—Jock Reynolds
Director
June, 1998

in Joel
piro's studio,
York.

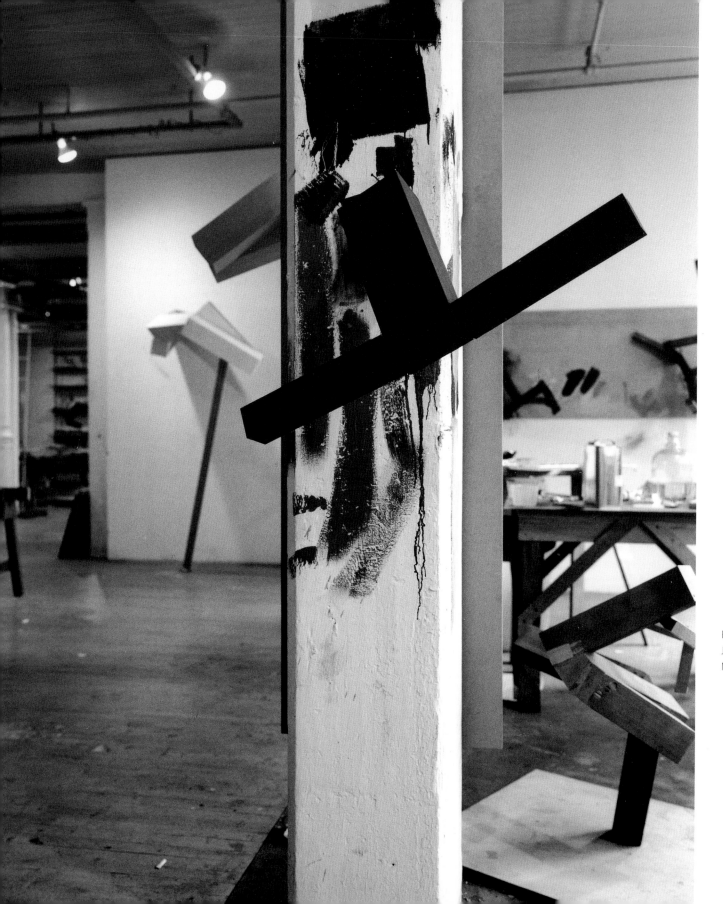

Pages 10-15: Views of
Joel Shapiro's studio,
New York.

10

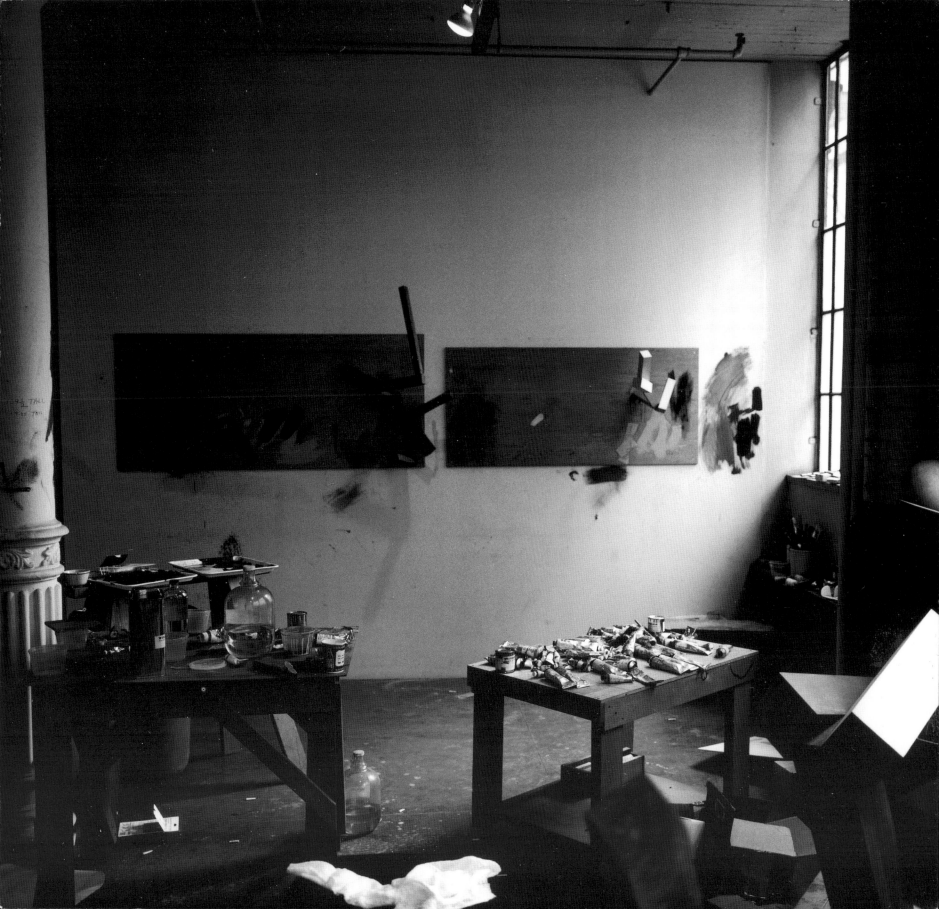

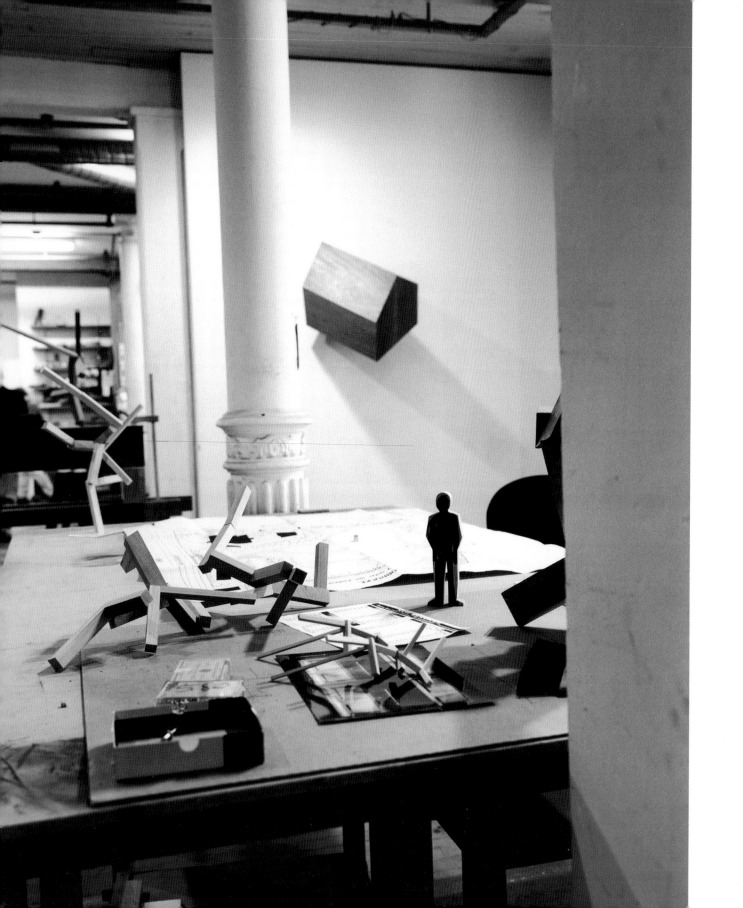

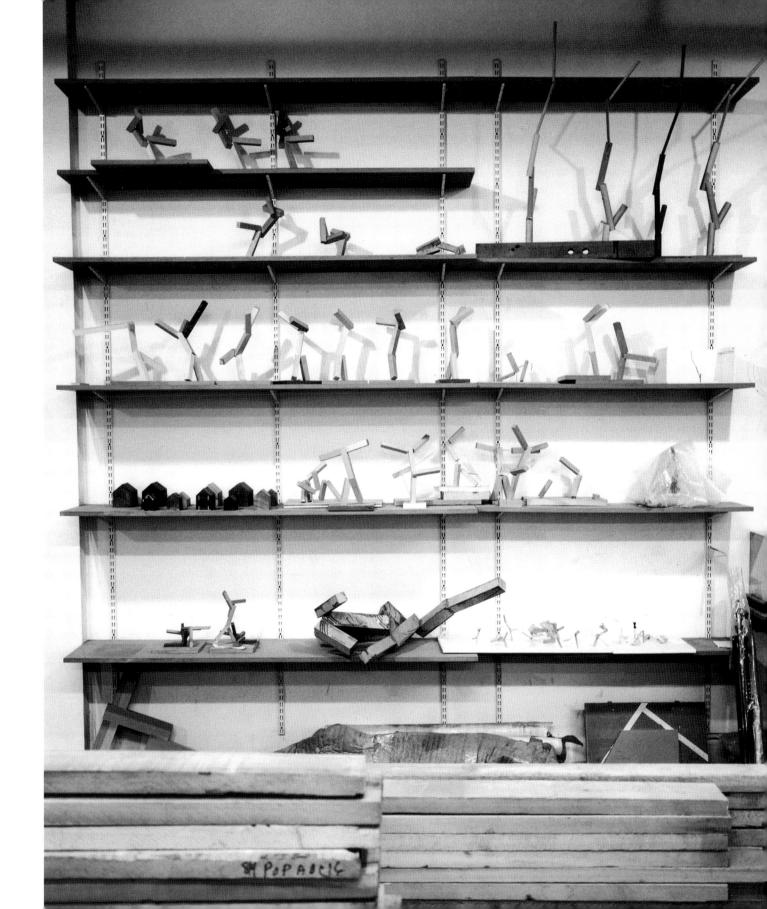

13

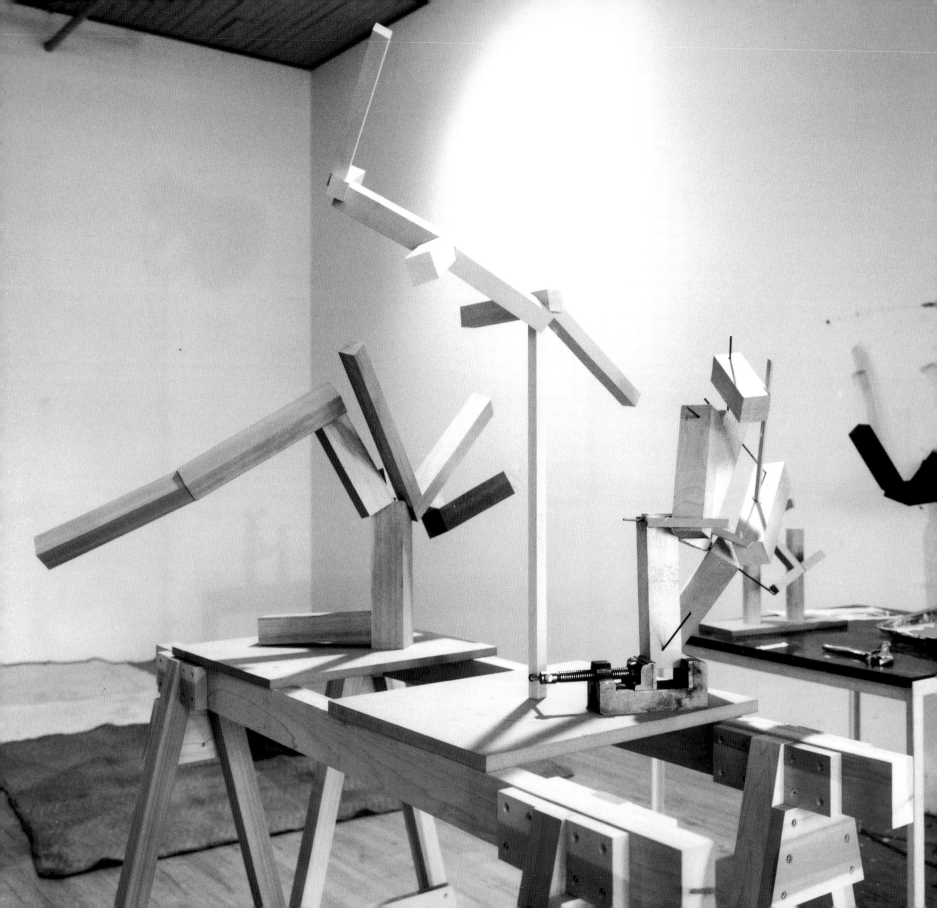

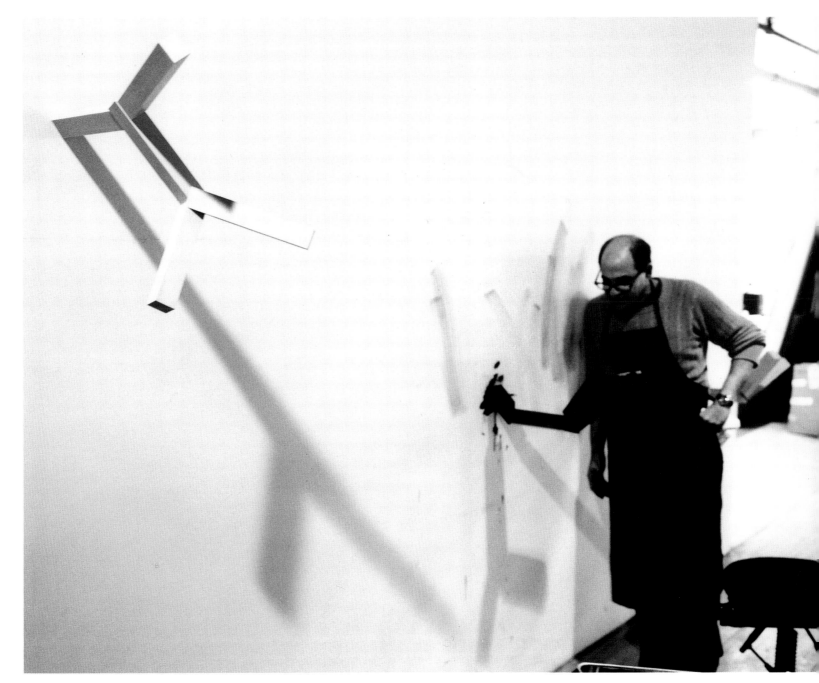

Following page:
Jock Reynolds and
Joel Shapiro
installing *Joel
Shapiro: Sculpture in
Clay, Plaster, Wood,
Iron, and Bronze,
1971-1997* at the
Addison Gallery of
American Art,
fall 1997.

15

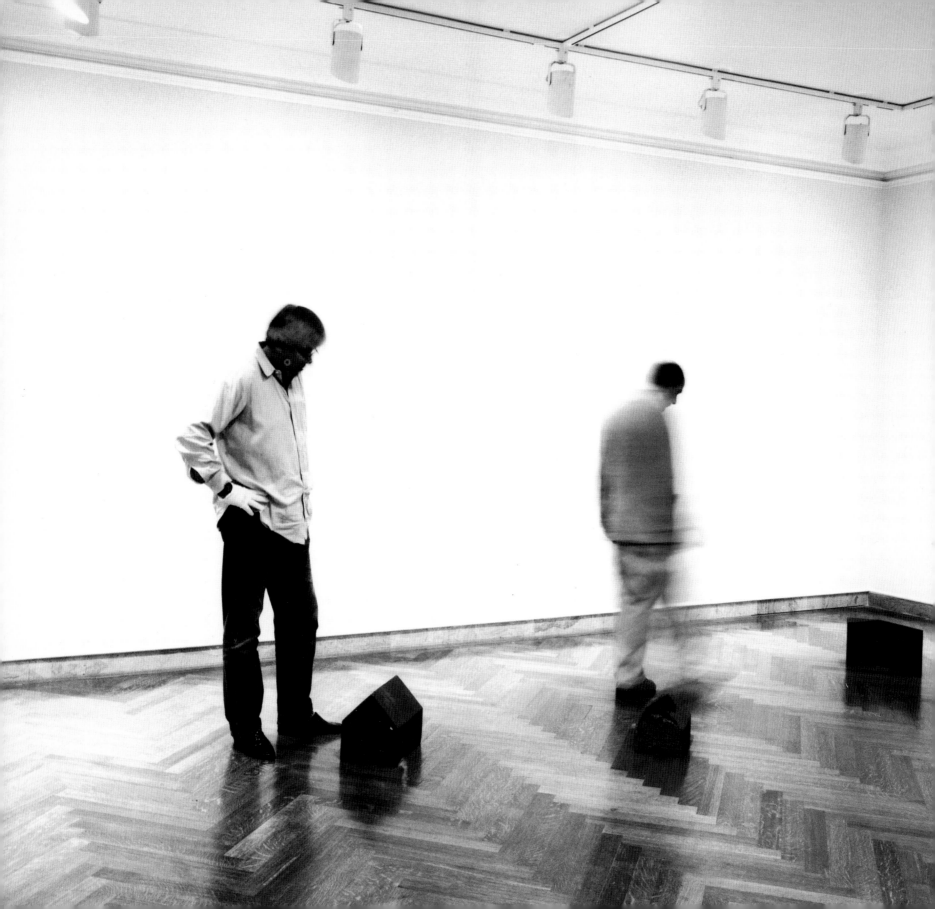

Joel Shapiro:
In Conversation

An edited selection of e-mail exchanges and studio interviews conducted by Joel Shapiro (JS) and Jock Reynolds (JR) during the winter and spring of 1998

JR: I still remember some of my first reactions to seeing your work long ago in SoHo. As a young artist in the early 1970s, I began traveling to New York from San Francisco whenever I could, trying to stay abreast of shows in the East. I happened to arrive in the city once when you were showing pieces such as untitled (chair), 1974, untitled (house on a shelf), 1974, and untitled (house on a field), 1975-76, at the Paula Cooper Gallery. I was fascinated by these pieces and how you had arranged them and some other small bronzes in a very sparse installation. Let me share some of the reactions I had to your work back then, and then ask you some questions about the exhibition and artist-in-residence project you've recently completed here in Andover.

One of the first thoughts I had when seeing your untitled (house on a field), 1975-76, was to draw a connection between your sculpture and Alberto Giacometti's *City Square*, 1950. I've always loved the way Giacometti arranged his five delicate walking figures in this work, freezing them in a moment of anticipated passage of one another upon that thick slab of modeled bronze. His base creates such an expansive and energetic space for the five figures, and wonderfully takes leave of the standard sculptural convention of simply placing the human figure atop an elevated pedestal of some kind. The "place" Giacometti provides for his figures in the city square becomes both real and metaphoric. The image and form suggest to me the very real connections all human beings have to the crust of the earth and the forces of gravity that ground us as we navigate daily among other human beings by choice and necessity. Even the gaits of Giacometti's figures, arrested mid-stride, suggest a direct physical bond to their space in the square and the world, exaggerated as they are by the way the artist modeled the rise and fall of each of their steps.

When I first beheld your lone little house, placed on its small but seemingly vast landscape of bronze, your work too seemed to be strongly grounded in both real and metaphoric worlds. The sculpture immediately prompted me to recognize the notion of home, a subject we know as a basic architectural form and the complex institution within which we engage ourselves intimately with our families and friends. Somehow, with a great economy of means, you were able to summon these subjects forth for me in their full emotional

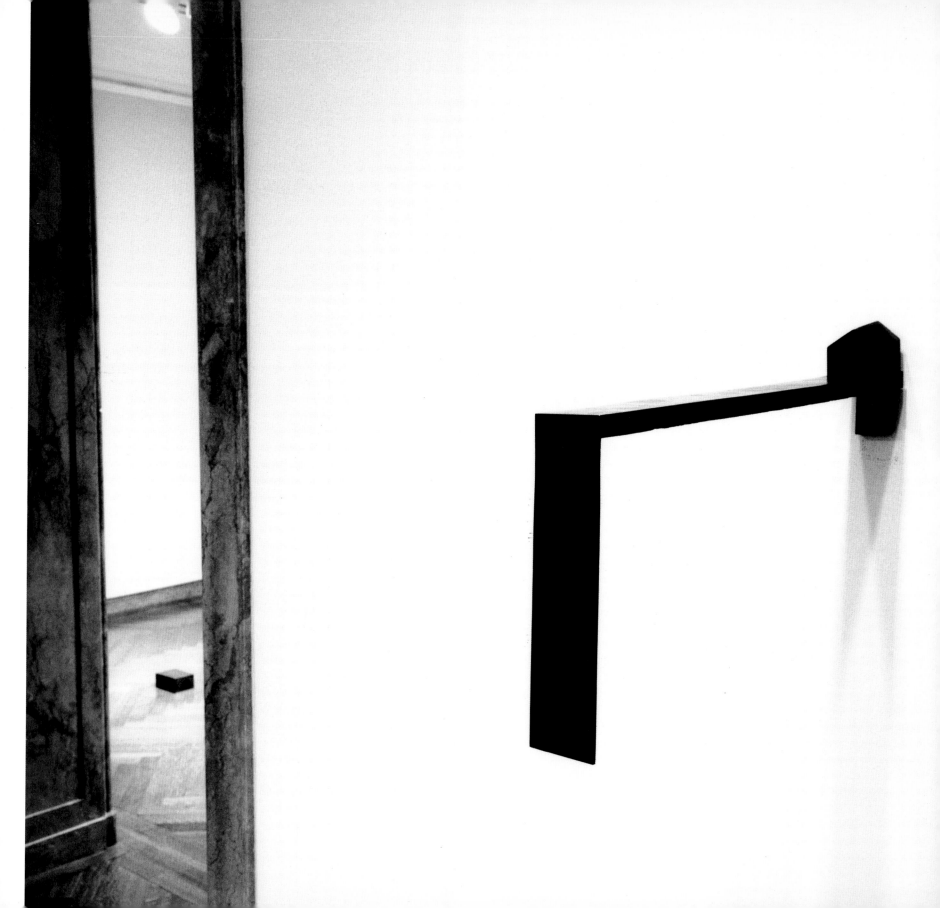

complexity, presenting them as you did within the austere and pictorial space of your sculpture. I've always wondered if Giacometti's work helped instigate some of your first sculptures, works that began to engage such great expanses of real and psychological space?

JS: If I begin to think back about what instigated work, I think every artist, particularly young artists, have certain historical models that reinforce their own work. I think early sculpture of mine like *75 Pounds*, the weight piece that you exhibited in the Addison's *The Serial Attitude* show, probably used Brancusi "the idealist" as a model—at that time I was interested in fail-safe work. I was too timid and fearful to be intimate. My early clay work and my interest in process led me to a more intimate place, where I had to project the personal into form. Giacometti of course would be the historical model for this. I recall looking at *Woman with her Throat Cut*, 1932 and being so overwhelmed by the experience of the sculpture that I could not really differentiate the parts or analyze the form. I would think every artist would want to emulate that level of intensity. When I began to use imagery, I think the critical issue was to keep the stuff the size I made it rather than alter it because of some external factor. Insisting on that helped create the dialogue between the actual and psychological space that you refer to in your question. The symbolic narrative in early

Giacometti, combined with the delicate but perfunctory means of making the work, still intrigues me. Think of *The Palace at 4 A.M.,* 1932-33. How can you create such powerful experience through whittling? It's not so much the way the form is made, but the relationships between the forms and between the forms and the artist (the surrogate perceiver) that are so interesting. The work is so matter-of-fact, modest, and profound.

JR: It's interesting that you recall Giacometti's *Woman With Her Throat Cut*. I too was unnerved by this sculpture when first viewing it. It's rare that we see a supreme act of violence so clearly portrayed in such powerful sculptural and emotional form within modern art. I realize tonight, pondering your comment on this piece, that I have never yet carefully examined how Giacometti actually composed and crafted this work. Scrutinizing the image in that way still seems tantamount to pausing at the site of real human slaughter—not something I want to do. The piece is that graphic and disturbing! Interestingly, another modern piece of sculpture, David Smith's *Structure of Arches*, 1939, a work in the Addison's collection, mines this same Giacometti sculpture for a similar vocabulary of abstracted figurative forms. Yet Smith's early work, although beautifully composed, carries little of the same emotional baggage. There is no real terror in its forms, which although

19

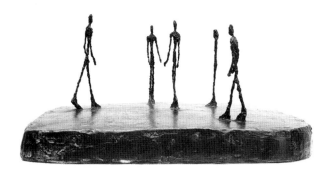

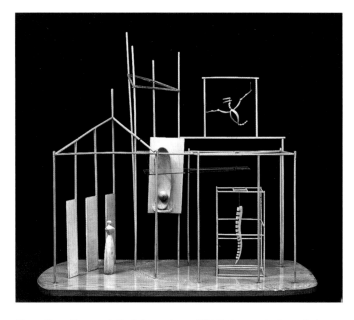

Above: Alberto Giacometti, *The Palace at 4 a.m.*, 1932-33, Construction in wood, glass, wire, and string, 25 x 28 1/4 x 15 3/4 in., The Museum of Modern Art, New York. Purchase. Photograph © 1998 The Museum of Modern Art, New York.

Top left: Alberto Giacometti, *City Square [La Place]*, 1948, Bronze, 8 1/2 x 25 3/8 x 17 1/4 in., The Museum of Modern Art, New York. Purchase. Photograph © 1998 The Museum of Modern Art, New York.

Top right: Alberto Giacometti, *Woman with Her Throat Cut. [Femme égorée]*, 1932, cast 1949, Bronze, 8 x 34 1/2 x 25 in., The Museum of Modern Art, New York. Purchase. Photograph © 1998 The Museum of Modern Art, New York.

Right: David Smith, *Structure of Arches*, 1939, Steel with zinc and copper plating, 39 5/16 x 48 x 30 1/4 in., Addison Gallery of American Art, Purchased as the gift of Mr. and Mrs. R. Crosby Kemper (PA 1945), 1982.162.

formally powerful, don't vividly suggest the devastating emotional power of a human body portrayed in its final agonized throes—with head, neck, spine, and legs arched upwards, frozen forever in a moment between life and death. Don't you think that there is something about how Giacometti somehow holds and suspends human movement and events in time that goes to the core of his work's great narrative and emotional power?

JS: Thinking of Giacometti, it is the humanist aspects of his work that interest me, the artist struggling to digest experience and then realize it by searching for relevant form. Sometimes Giacometti seems to revert to an undigested past to figure out the present. You believe his expressions, however, unlike authoritarian artists, he does not insist and browbeat you into submission. I sort of agree with you about the "holding and suspending" feeling that is produced in *Woman with her Throat Cut*. It is the fact in the flux of forms. Empowering the tentative is rewarding and I think hard to do because it is painful. I think the critical issue, however, is the necessity to generate form, resulting in a configuration that can elicit, recall, or jolt. I should say that this particular Giacometti is especially convincing: the disjointed nature of the parts, the sculpture's relation to the floor. The comparison you make to Smith's early sculpture is apt, but his early homage to Giacometti seems blunt, more

aggressive, and not so surreal. American surrealism is not always so convincing. New York School artists often seemed strident when creating in this realm. I guess they were playing catch-up with their European colleagues. In any case, the story line in Smith has always been subservient to his struggle to generate form, which sometimes seems very picture-bound. His late work, however, which of course I have run into, is different. We can talk about that later if you want.

By the way, how about Bernini's *The Ecstasy of St. Teresa* and *Woman with her Throat Cut*—as orgasmic. That's a sort of universal experience. Death is only observed by the beholder—only the dying experience death. Maybe Smith is about the pre-orgasmic or the priapic. Giacometti and Smith are both great artists who have generated profound bodies of work. I can be glib, but when does the theatrical become convincing? When it touches some deep human experience. I'm not entirely interested in work that is rational. Since form is fact. Is that theatrical?

JR: Going back to Giacometti's *City Square* for a moment, I know that it is my acute visual anticipation of what might or might not ensue between his five figures—were they to come to life walking in their metaphoric public space—that gives me so much to think about when I ponder this work. I have a very similar reaction to certain great photographs I love, like Robert Frank's *Canal*

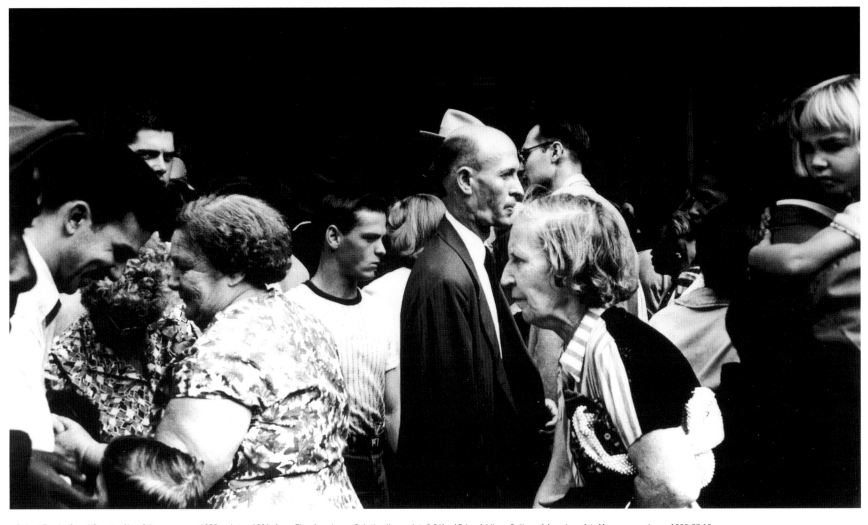

Robert Frank, *Canal Street—New Orleans,* neg. c. 1955, print c. 1981, from *The Americans*, Gelatin silver print, 9 3/4 x 15 in., Addison Gallery of American Art, Museum purchase, 1989.77.19.

Street—New Orleans, from *The Americans*. This picture momentarily freezes a group of people who are walking along a crowded city street in close proximity with each other, yet seem completely distanced from each other. These citizens aren't making eye contact and seem to be in very different emotional spaces as they narrowly avoid jostling each other. Both of these works—Giacometti's and Frank's—like many of your early bronzes, seem loaded up with profound feelings of loneliness, separation, and longing. They carry me into narrative readings, some quite dramatic in nature, of what might be afoot in these situations. I find myself stirred to think about how readily people can isolate themselves in their places of work or homes, and how quickly individuals can retreat within themselves in public, remaining adrift or focused in a world of interior thought, while pursuing a physical course through urban streets and structures. What do you make of all this?

JS: Work is engagement with isolation. You grapple with form until you find some resonance. Individuals walk down the street engaged in the common pursuit of self-reflective discourse. Gnashing over the past, fantasizing about the future while trying to negotiate the present. The artist lays his past into the present; it's active, and you hope for a response, which you always perceive as tepid.

JR: I am still thinking of your early years in New York and remembering that you were perhaps the first artist that Alanna Heiss invited to show at The Clocktower gallery space in TriBeCa. I wonder if you recall how and when you first decided that you wanted to arrange your own installations of your sculpture? And how did installing your own work come to affect the content and scope of your sculpture as your art grew and matured throughout the 1970s?

JS: As soon as I realized I was making sculpture (or trying to) and not making objects, I began to think of how to install the work. Work is made in a certain time and place, and with a particular order or layering of thought. Let's call it the cumulative history of the sculpture. That is something you try to convey when you exhibit in public. I knew more about my work than other people, so why wouldn't I do the installation? If the work was self-protective then the installation would correspond. It is all part of the work. The rest is about taste which develops with experience. Let's face it, taste affects the perception of the work too.

JR: Joel, let's be specific and talk about The Clocktower.

JS: Alanna offered me the first show in The Clocktower. The space was raw and had an iron spiral staircase that, as I recall, penetrated three

Right: *Ladder,* 1973,
Basswood, 11 1/4 x 1 1/2 x 1/8 in.

Bottom: *Two Bronze Birds,*
Each: 1 3/4 x 3 3/4 2 3/4 in.

Far right: *Bridge,* 1973,
Milled grey cast iron,
3 1/2 x 22 1/2 x 3 in., installed
in the exhibition *Joel Shapiro,* at
The Clocktower, Institute for Art
and Urban Resources, New York,
April 12-April 28, 1973.

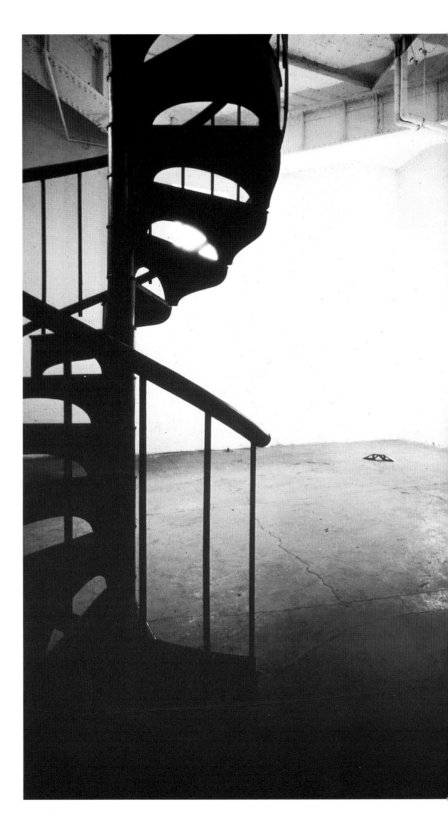

floors. Each floor above was progressively smaller, culminating in the top floor which was the actual clock mechanism. It progressed from public to intimate—think of the mechanical workings of the large clock as an industrial brain. Very loaded space and a perfect foil for my foray into change and transport. Screw the volume of the space! I would just try to hold it down with the small bridge. I kept the original size; however, I did machine the sculpture from a solid block of iron—ritual gestation.

After going up the spiral stairs, I leaned a ladder against the wall. On the next floor, an even more strange space, I installed two bird-like objects to be picked up—one for the right hand and the other for the left. After that you could climb to the Clocktower or go out on an expansive terrace and get some fresh air.

JR: It's interesting to me that you have continued to show your work widely in alternative spaces, commercial galleries, teaching institutions, and museum venues. You have done so in a great variety of architectural spaces both inside and out. How did you begin to seek out ways of making and then siting your work in places where you could dramatically shift your sculptural expressions downwards and upwards in visual scale and still gain for them the considerations of monumentality and intimacy you seem to relish so much? Have you arranged all of your installations and shows since 1970 onward? Have you had to negotiate this approach to showing your work, be it with your first dealer, Paula Cooper, or with other curators and the PaceWildenstein gallery, with whom you've worked in more recent years?

JS: The first time I exhibited at the Paula Cooper Gallery I was so scared that the work and the installation were the same (shelves). I established a fixed point of view. I began to loosen up as my sense of self and work evolved. Paula was very sympathetic and basically would give the gallery over to the artist. Of course, I was interested in her opinion, particularly when in doubt. She was helpful and not obtrusive. I am always interested in the opinion of the person most familiar with the space.

There are multiple options in an installation and I try to establish meaningful relationships among work. I am really interested in the whole exhibition reading as a projection of thought. I think one of the problems in the art world is that people function as if everything is familiar. The smart thing to do is try to elicit what is new rather than reinforce what is known. This struggle impacts the installation and affects responses to work. Screw avant-garde—I would simply like to check my own gravitation to the familiar. When installing I think about all this stuff.

It was fun to install with you because you had a fresh point of view on the work. The sculpture you selected for the Addison had not been seen for quite a while. Much of what had been seen was

compromised by limitations of the exhibition space, so the capacity of the work to express itself was throttled. The Addison's galleries are sympathetic. Most gallery and museum space is second rate, particularly for sculpture, where ambient space is part of the work. To get shoved against a wall or placed on a plinth marginalizes three-dimensional work. The propensity to turn sculpture into objects should not be underestimated. Painting, with its imaginary but framed world, seems to fare better.

JR: Do you like working with museums?

JS: It is always nice to do an exhibition, but museum curators and institutions have heavy obligations to preserve and protect work and responsibilities to educate the public. It is complicated to preserve and protect while also seeking to provide the very best experience of an artist's work. My big gripe has always been with how sculpture has often been pushed to the side or cordoned off for the sake of pedestrian traffic and security. I think architects, artists and curators could work together to find more intelligent solutions than we usually get. It takes an awful lot of time to do this. In the end, I am more interested in what I do in my studio, and am generally slightly embarrassed by how it is revealed in public. And I think that the strength of a sculpture usually has to overwhelm the imperfect context that it is placed in.

Untitled, 1994, Bronze, 21' high, Installed at Sony Music Entertainment Corporation, New York.

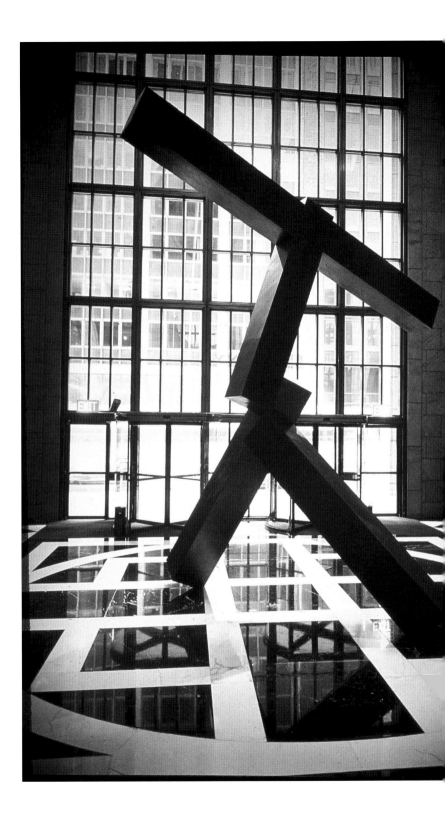

JR: But you've also been producing public commissions in recent years. I've seen the large piece you did for Sony in New York, one produced for the entrance to the Kansas City airport, and the upturned house and figure you created for the Holocaust Museum in Washington. How do you approach working on sculptures for contexts such as these?

JS: Well, you rise to the occasion and sometimes fumble. I've done a few commissions and they are nice because they pull you out of the self-referential nature of the studio—at least my studio. Unfortunately, I seem to be my own subject more or less. For a commission you have to think in a bigger context—you adjust your frame of reference to encompass the architecture, the people, the traffic. It is sort of like an installation, but of course in an installation you are arranging what you have already done. In a commission external factors enter the experience. It is always rewarding and I think it opens you up. The public seems to have a difficult time with a lot of public work. I think this is understandable for many reasons. There's not a tremendous amount of outreach on the part of artists and commissioners, art education is not emphasized in the schools, and also I think a lot of the work is obtrusive and doesn't give very much. If you are going to work in public you have to be convincing. Once you've had an idea that resolves the problem of the work in

View in Joel
Shapiro's
studio,
New York.

space, it's easy to lose interest when the work goes into production. You have to remain involved with the work. Otherwise the work will look manufactured and lose reference to its point of origin. Work I make in my studio has—a sense that the form was struggled for—there are traces of the hand, of tool marks. All of that stuff is retained in the casting. If I am working on a larger scale piece, I don't simply make it bigger, I have to amplify the sense of the entire process, so there is a sense of how it comes together. The work has to have vitality. People have to sense that.

Playfulness and spontaneity have to carry over. Intimate thought projected on large scale is exciting.

To get beyond human scale was tough for me. First I had to get beyond mental scale. I stacked figurative forms—doubling up—so one element ascended while the other one descended. Always counter faith! Avoid the colossal—use parts cut from wood that bodily experience can comprehend. The sculpture at the Holocaust Museum in Washington is large but the parts are understandable. Their joining is about interior thought. The sculpture at SONY verges on the colossal but the space requires it—that sculpture is so big you can't see it in one shot, so you have to deal with it in fragments. In Kansas City, the piece on the median has to be seen while driving. No one is getting out of their car for this sculpture. These are very different contexts for my art. They stretch me to think more about myself and the nature of the viewer's experience.

JR: I was recalling over the weekend how we conceived this survey exhibition of your sculpture here at the Addison. I know I wanted the show to be one we could assemble very freely from work you've retained for yourself and your family over the last three decades. I sensed that such a selection would somehow afford you a greater degree of psychological freedom to shake things up as we developed this project together. I began to feel this as you generously allowed me total access to your art storage areas during my multiple studio visits in New York last year. I know too that I've always been interested in what artists save and don't sell, even when they edition some of their work as you have done. Anyway, the more we talked, the clearer it became that your exhibition should be configured and installed any way you wanted it to be seen in five of the Addison's galleries—and then be re-configured—midway through the show's scheduled time on our calendar. I remember us agreeing that this approach would enable students and public visitors to better understand how you think and work over time when arranging your works in response to a particular architectural setting. I was also eager to see the visual groupings and narratives you might create using a full array of your past work—including whatever new sculptures you might create in Andover as one of our Elson visiting artists. Since you've created much of your art in a broad variety of classical sculptural materials—clay, wood,

Pages 29
Views in
Shap
stu
New

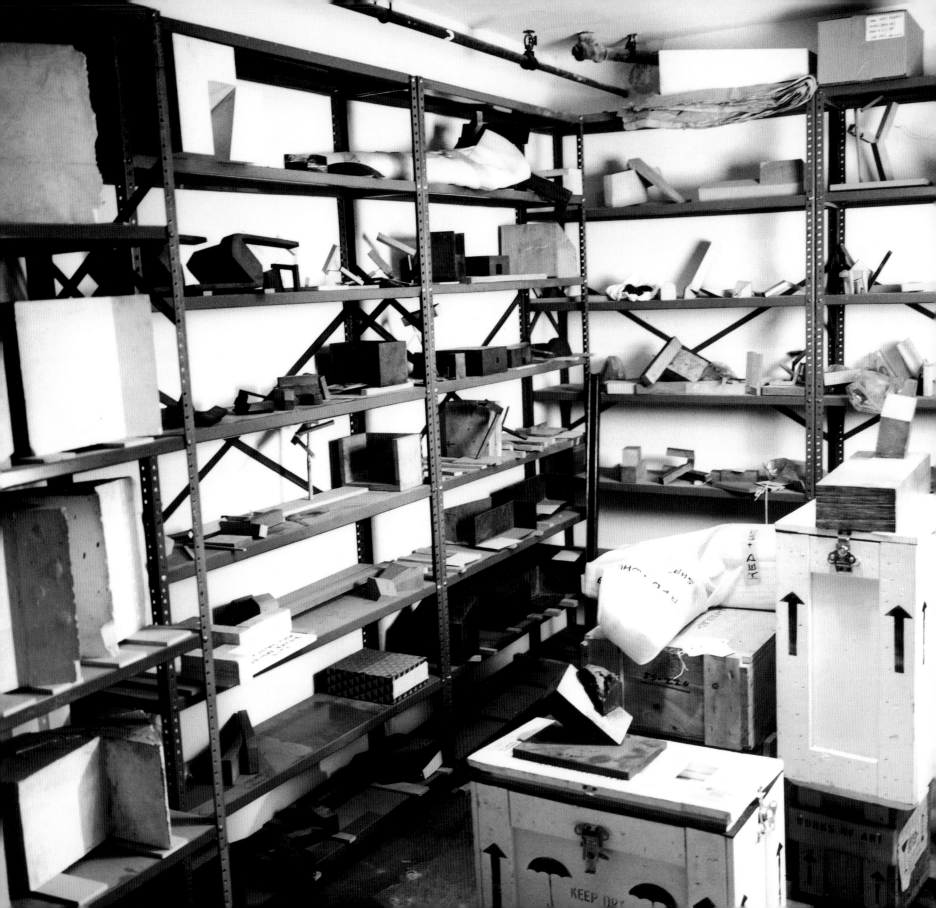

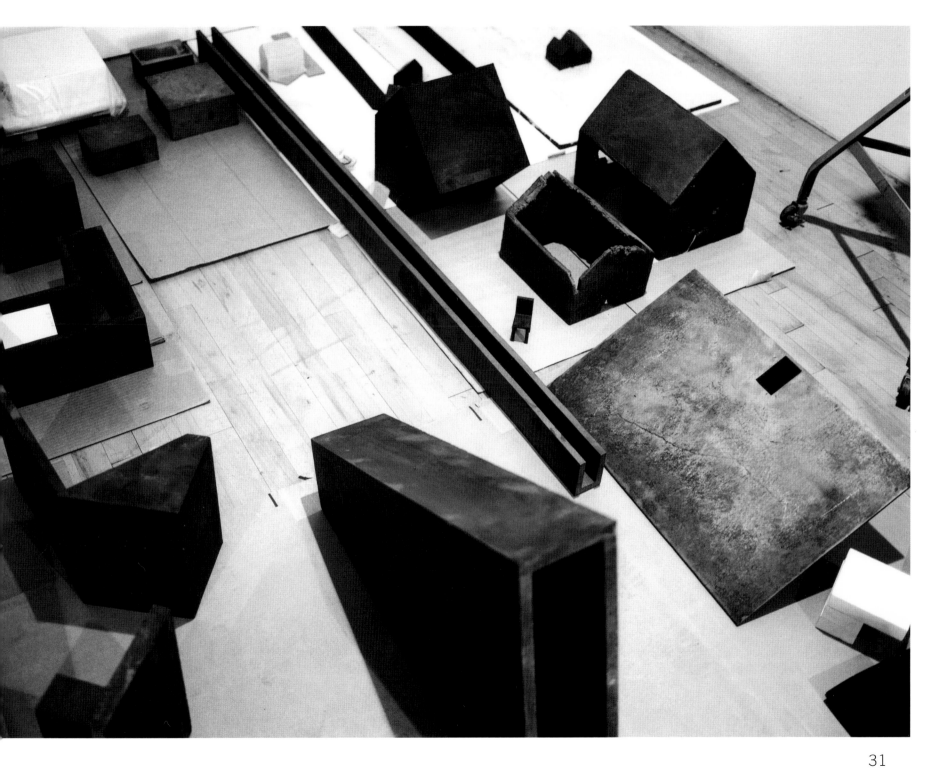

plaster, iron, and bronze—I wondered too how choices made across material expressions might affect what you would show here and/or want to make next. Most of all, I wanted you to feel free to strike out in whatever direction(s) made sense to you. All of us working here felt prepared to provide whatever installation assistance and support you might want from us, but we were also prepared to simply stand back and watch. God knows, when you arrived in the building and started wielding that big Johnson bar on your large plaster pieces, we all jumped back and ran for the packing blankets.

Now in retrospect, I'm wondering how you felt about the basic working parameters we established for your Addison project. Did they in any way affect what you did here in Andover and what you are now working on in your studio?

JS: At the Addison there was little preconception operating behind what you were interested in showing. Hence I think this project became more of a conversation among you and me and the work. I keep stressing that some of the installations of my work were compromised by the architecture and the kind of traffic that sometimes came with it. The Whitney space was particularly difficult for my smaller work, as I recall. They cordoned off the small pieces with strips of wood. Clearly that undermined the ability of the sculpture to function. The work was always mediated by some traffic device. The Addison is particularly

sympathetic: the galleries are not overwhelming, even the herringbone pattern of the floors helped to break the normal grid of a more conventional gallery. The space has dignity. But probably more important, the space is not controversial. What is particularly unique about the Addison is that it is a museum committed to American art—some of it the most avant-garde and controversial—situated in this well-established educational institution. I think this, in combination with the sympathetic space, may have helped assuage anxiety and doubt, allowing people to actually experience the work on some very human level.

I felt very much at ease while engaged in this overview of my work, realizing my strengths and weaknesses without the same level of hesitation and fear one experiences exhibiting work when it's first made. I think your willingness to make associations between pieces was productive. I also think this was reinforced by the flow of the space. The interrelationship of the work and its implications interest me more and more. I am much more interested in a body of work and how it unfolds than in the mastery of an individual work. Of course it's easier to see the stuff in retrospect than when you are actually doing it.

JR: Related to all of this, I was often fascinated by the students' responses to your Addison exhibition. Kids who came into the museum often engaged your sculptures in very

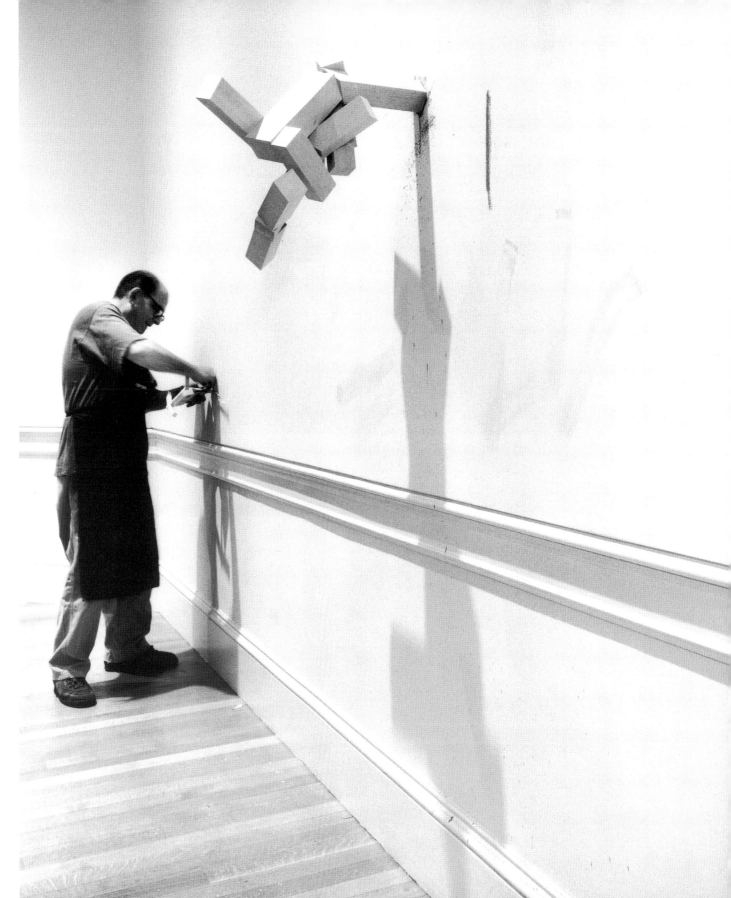

Joel Shapiro in the visiting artist studio, Abbot Hall, Phillips Academy, Andover, Massachusetts.

Pages 34-37: Joel Shapiro working and meeting with students in the visiting-artist studio, Abbot Hall, Phillips Academy, Andover, Massachusetts.

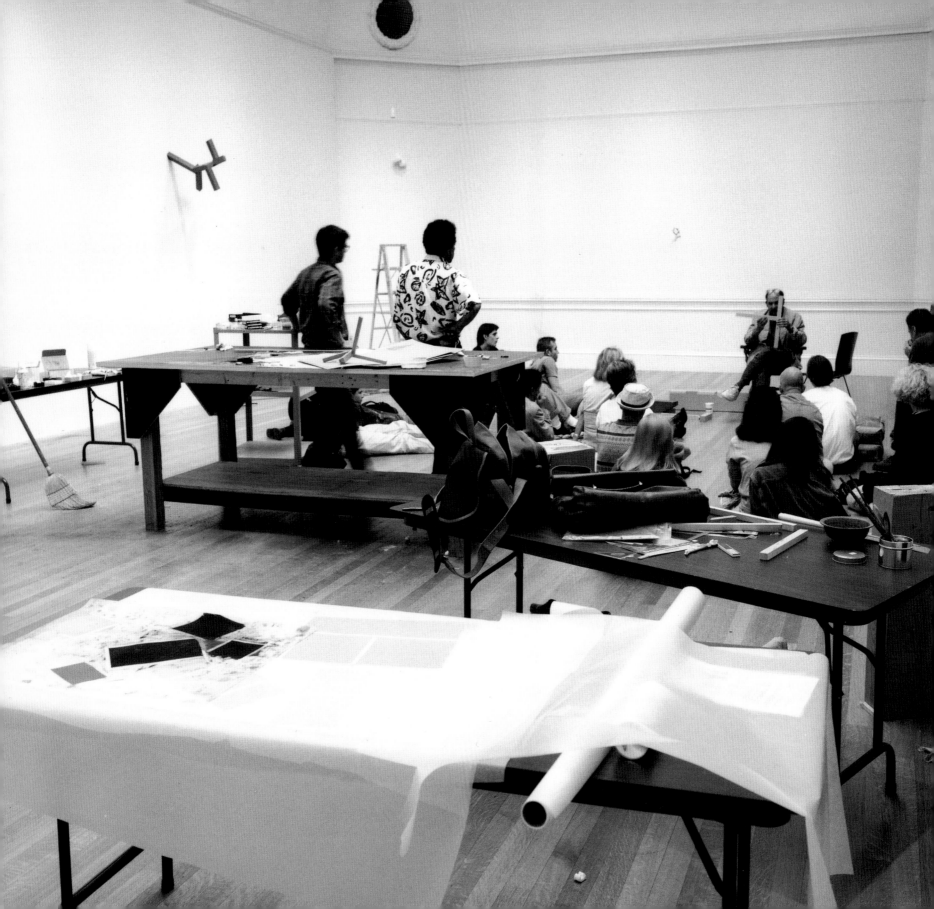

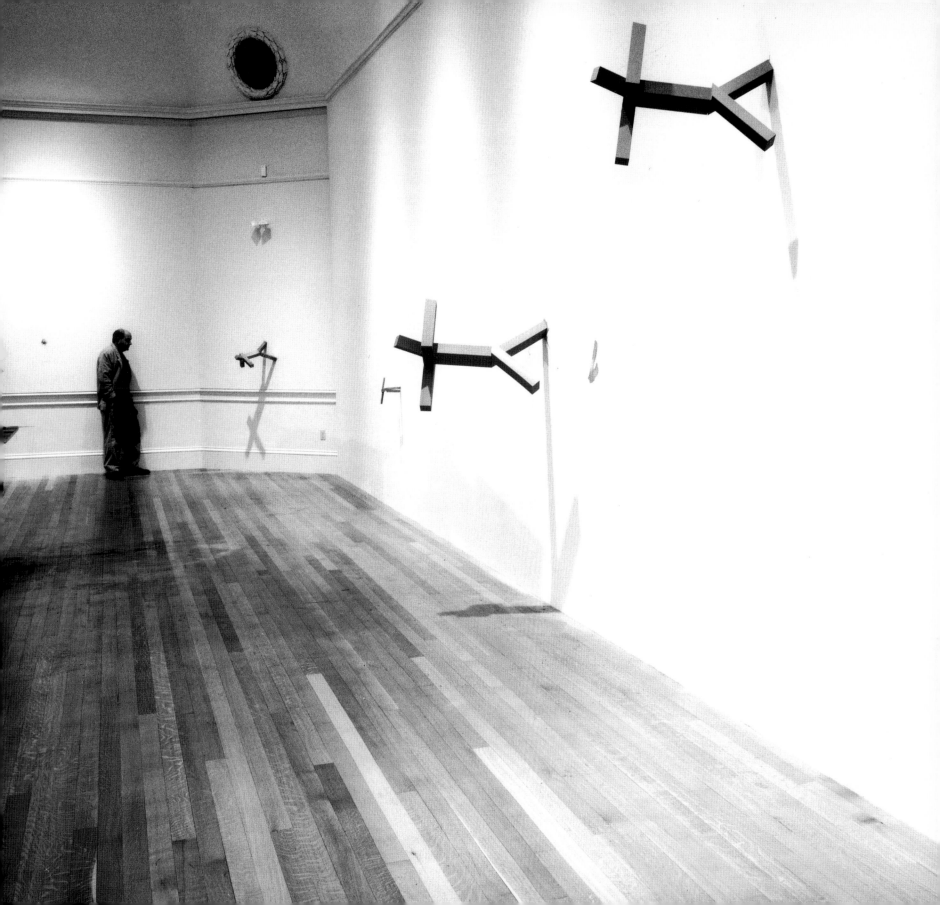

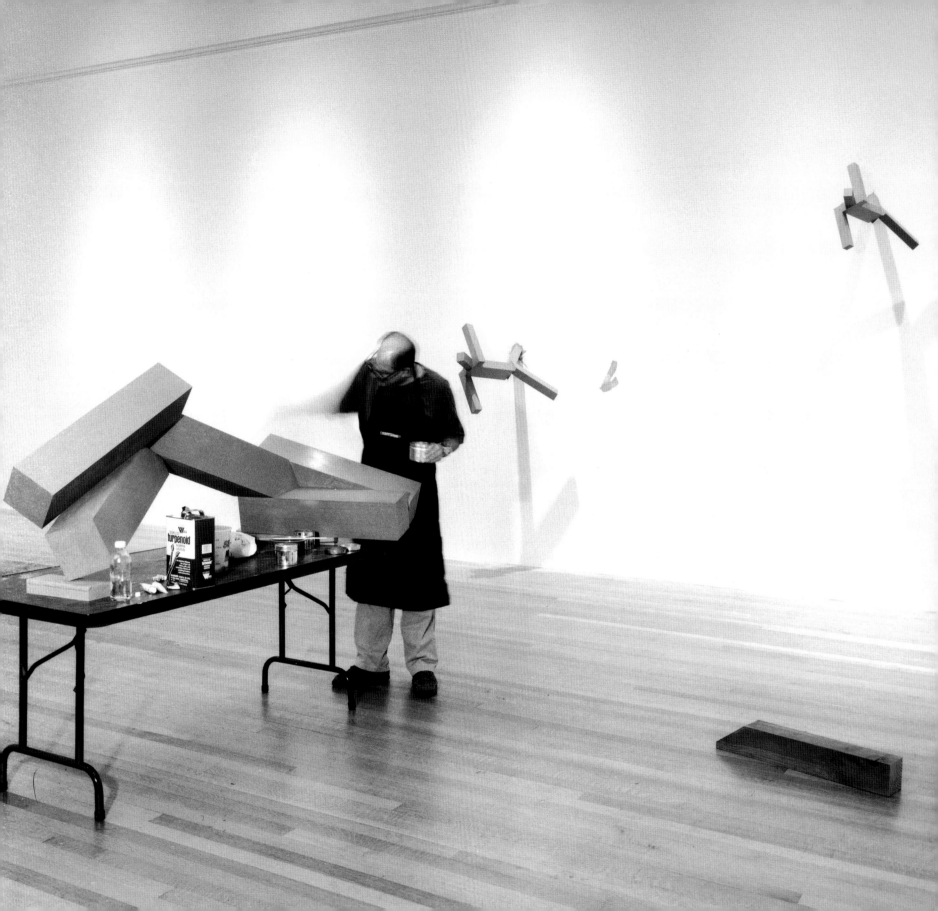

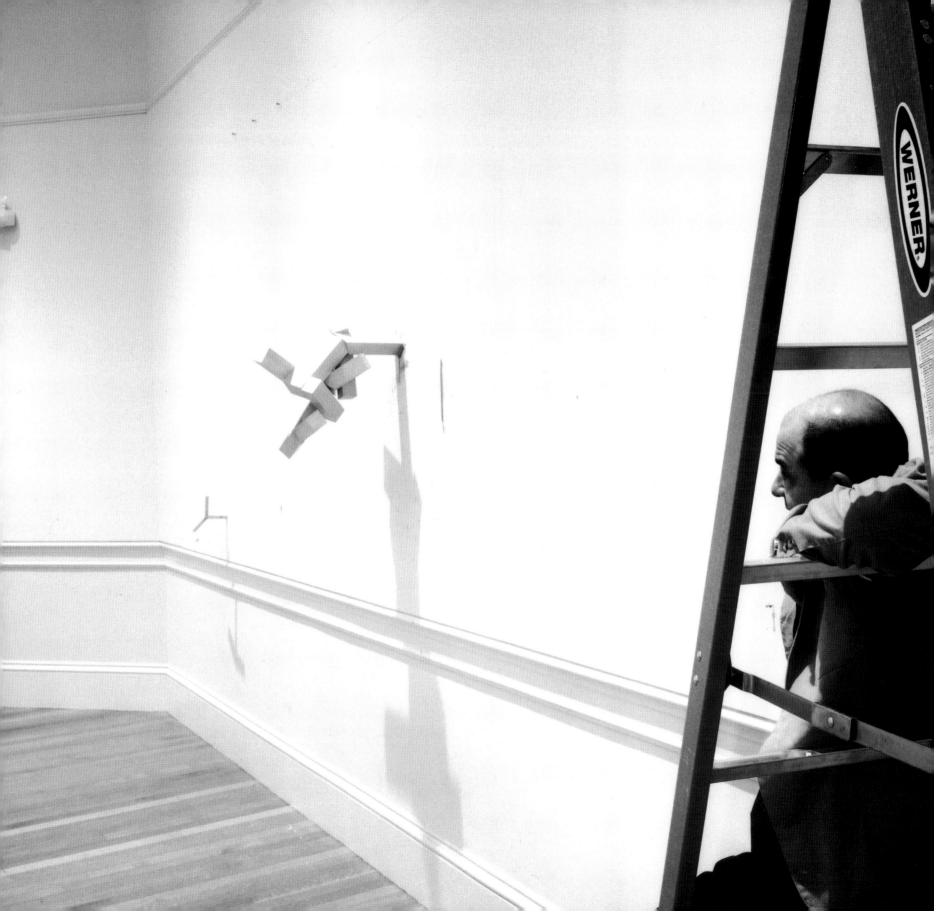

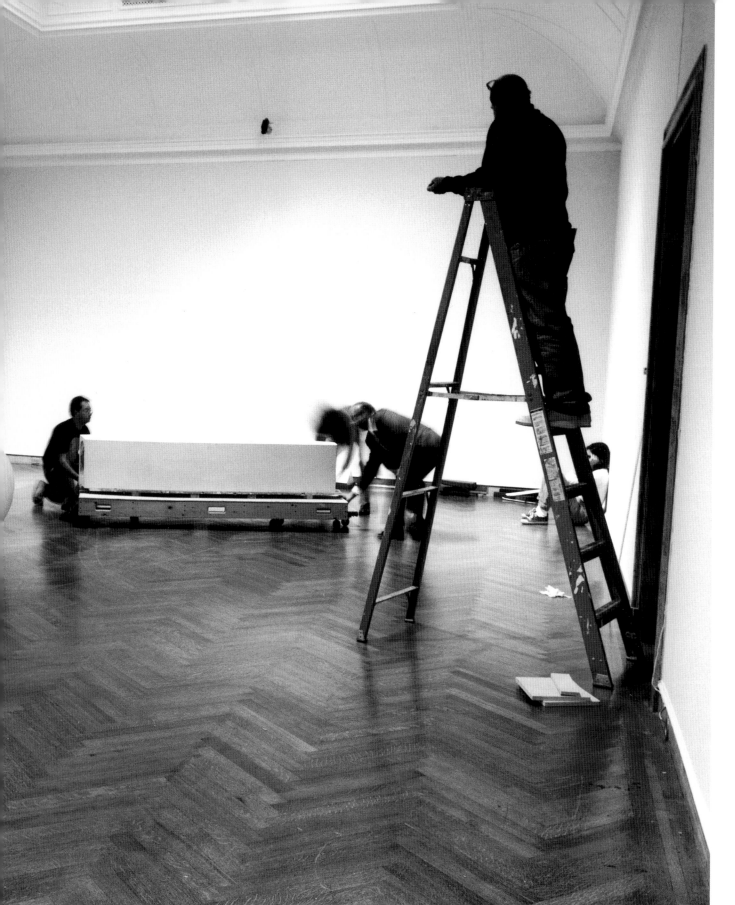

Pages 38-40:
Exhibition installation at
the Addison Gallery of
American Art, fall 1997.

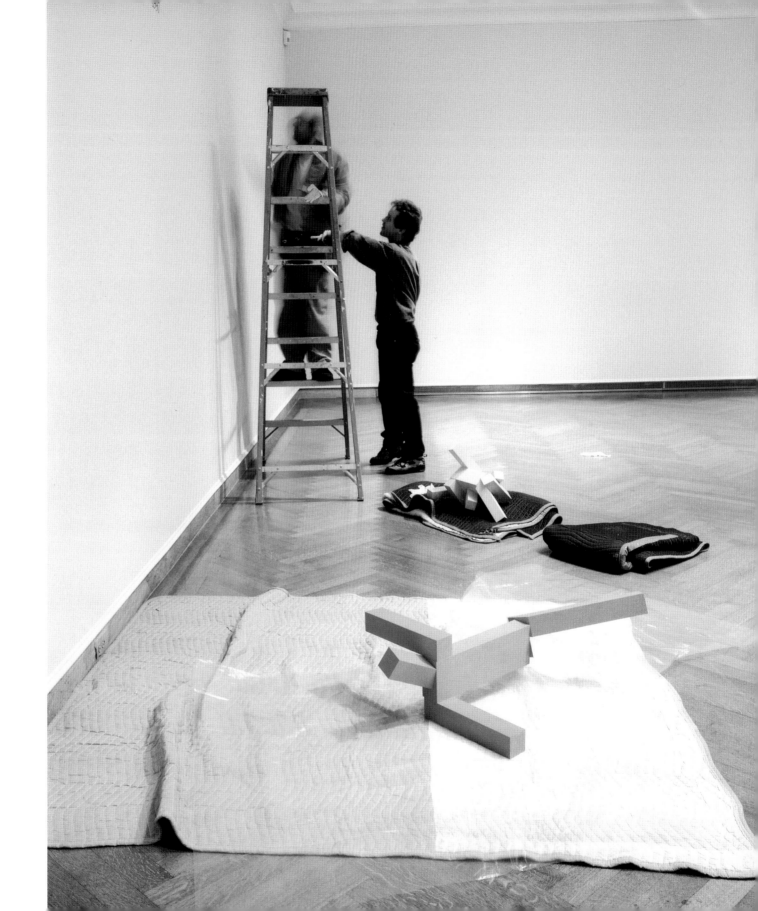

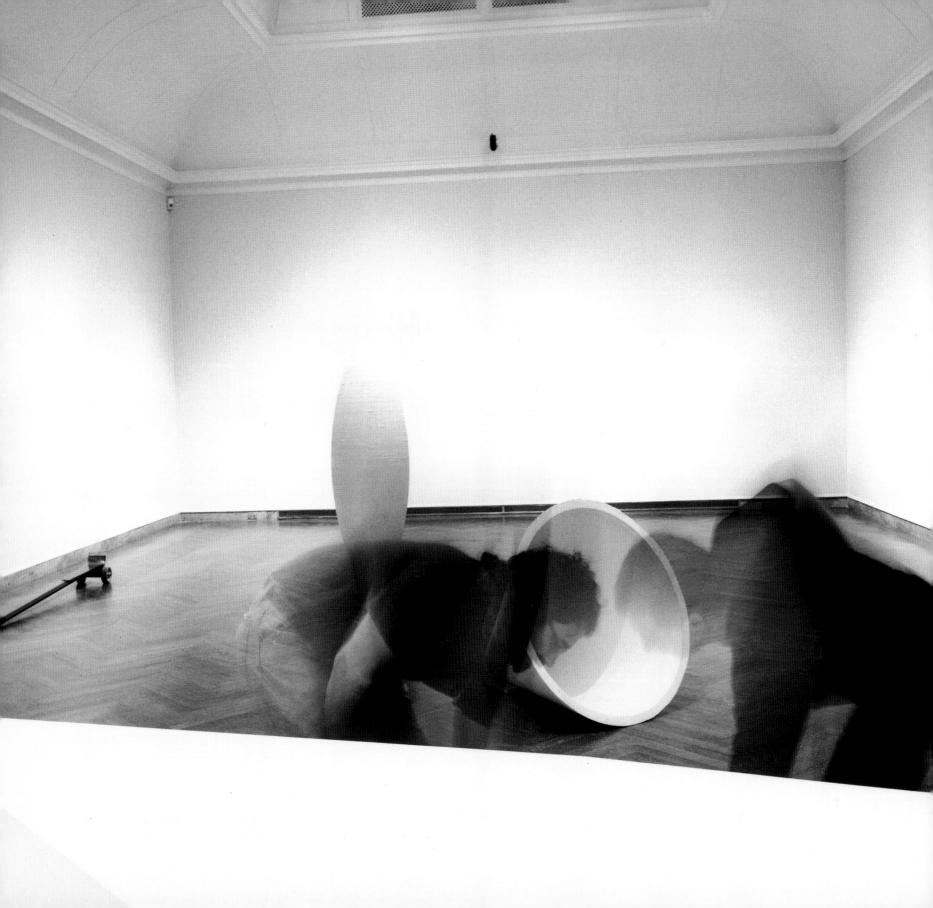

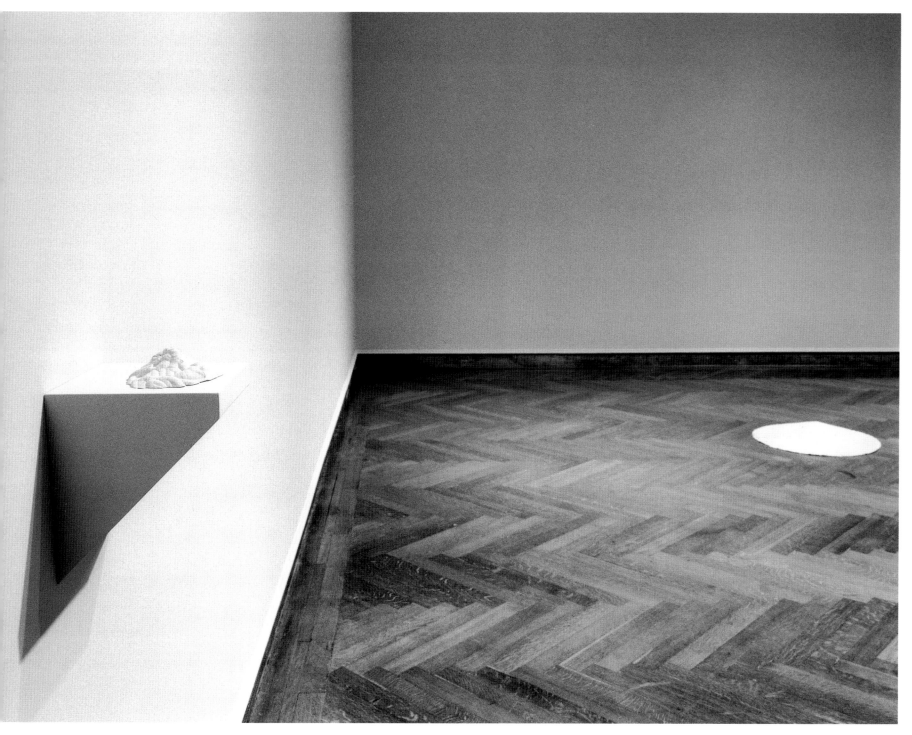

41

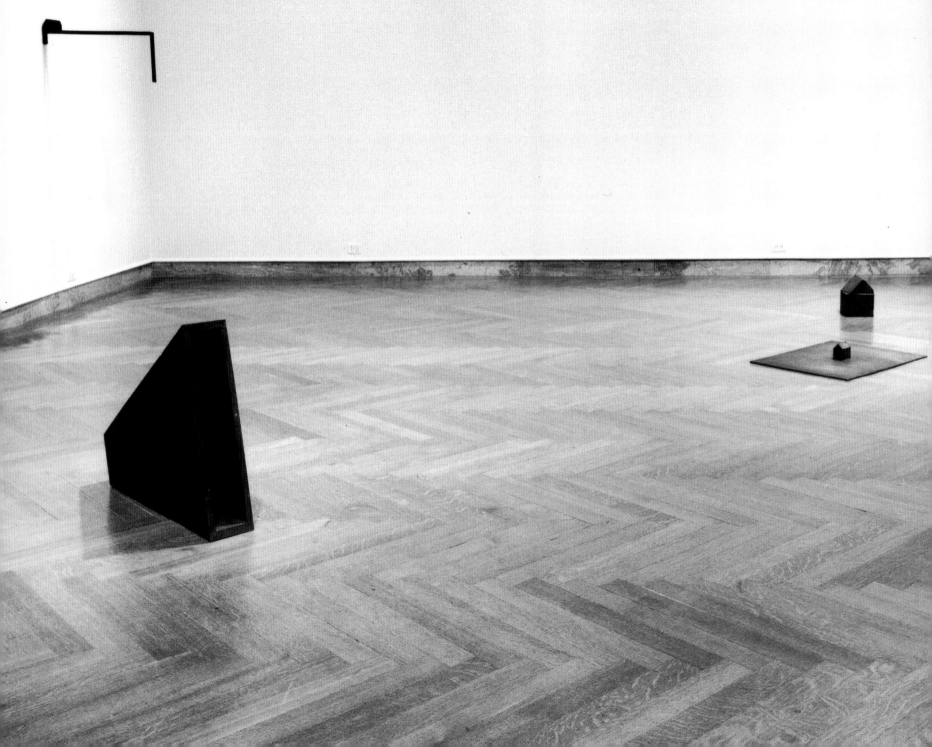

JOEL SHAPIRO: SCULPTURE IN CLAY, PLASTER, WOOD, IRON, AND BRONZE, 1971-1997

direct, physical ways. Our staff members would sometimes find them lying flat on the floor, carefully scrutinizing your untitled (chair) or untitled (house on a field), from eye level, merely inches away. At other times we'd hear elaborate stories being told as one kid would lead others around a room, describing what he or she felt was going on in the constellations of your work. I remember one girl pausing before untitled (house on a shelf) and talking about how this home and its family were perched precipitously on the edge of the earth, living at the end of a lonely street. She went on to assert that things weren't happy and right in this home, and interpreted all of this by noticing how your little house was crafted, how it was slightly askance and crooked in its relationship to the bronze roadway, and how the street ended abruptly in a thin right angle of bronze— dropped off to the floor. Her narrative and emotional reading of your sculpture was rich and full of nuance. It clearly arose from a very careful observation of visual facts. I was frankly quite surprised by how engaged this youngster and others became with your work. What do you make of this?

JS: It's interesting, although embarrassing a little, to see a child's response to my work. Of course, I would like to think that I am much more sophisticated than all that, however there is no question in my mind that I do access certain childlike emotions and motion as a basis for

sculpture. I've talked about this before, how my works in the Addison's galleries were made accessible—out on the floor—in a democratic space. The installation allowed kids to crawl around, get down on their hands and knees and examine the work closely. And since intelligent adults don't entirely forget their past, I think they can enter into that world mentally the same way the kids do physically. They don't necessarily have to crawl around on the floor.

Play, however, is an important component. Work is play, and I think when you're working, you're accessing your entire experience. There are lots of ways to understand art. At its best, art is a summary of human experience. You can look at it and really think about it, or think about it and then look at it, but kids do seem to have an immediate take on work. Of course the students going into the Addison Gallery are not exactly ordinary children. But maybe I am wrong in thinking this, since your staff brings so many public school children into the museum. In any case, all of these kids are probably having an experience that few children get to have. Art is such a tangible yet abstract concept, that I am sure early meaningful experience of art is profoundly important. Also, my sense is that the way art unfolds—its immediacy— corresponds with short attention spans. As a child, I was much more willing to look and discover painting and sculpture than to delve into a novel.

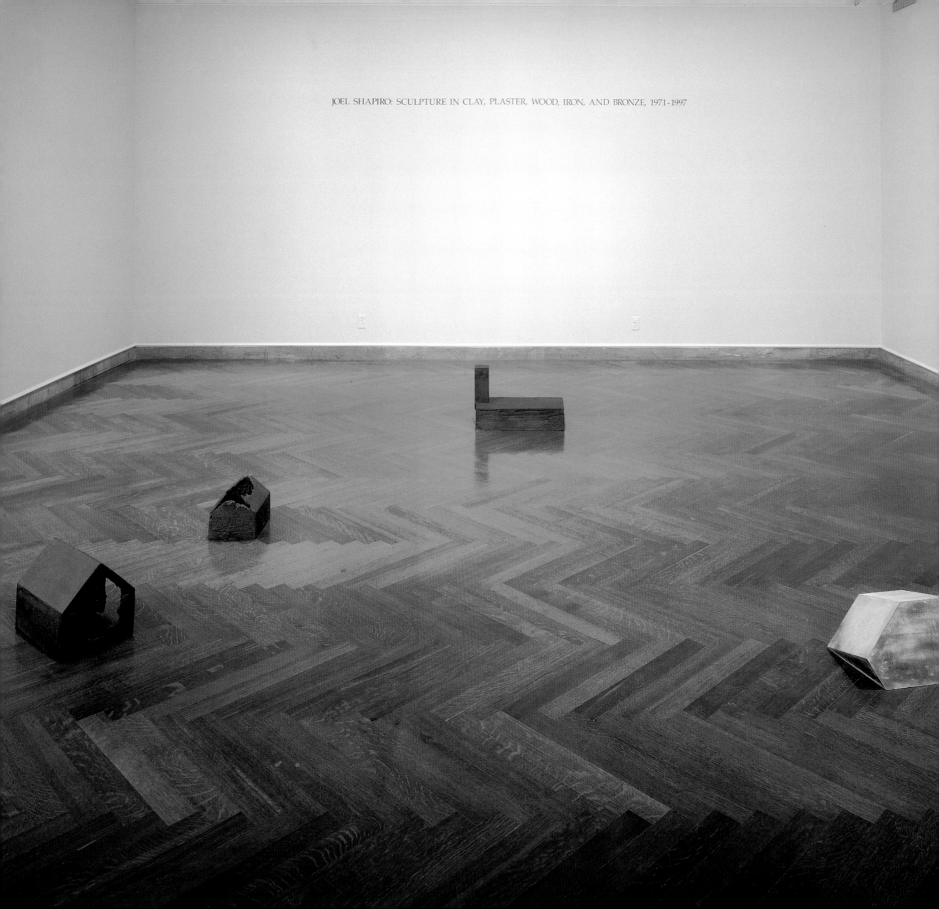

JOEL SHAPIRO: SCULPTURE IN CLAY, PLASTER, WOOD, IRON, AND BRONZE, 1971-1997

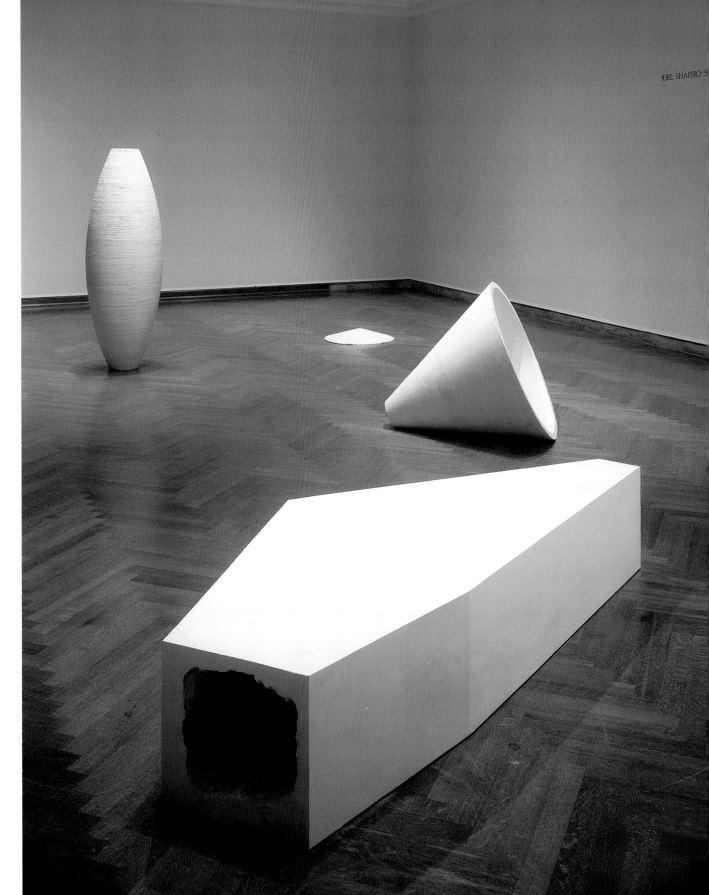

Pages 44-47: Views in
*Joel Shapiro: Sculpture in
Clay, Plaster, Wood, Iron,
and Bronze, 1971-1997,*
Addison Gallery of
American Art, fall 1997.

45

I think people can be quite empathic with work, particularly if they have had some experience making form. If you've played around with clay, it is infinitely easier, I think, to understand and relate to, let's say, a Giacometti.

JR: It's interesting to hear you reflect on the immediacy of experience you remember when first encountering art in your youth, as well as your description of the knowledge a kid can get through a hands-on engagement with expressive materials. These ideas clearly continue to culminate in your present way of thinking and working, wouldn't you agree?

JS: Yes, but the Addison installations had much more to do with my experience or somehow a synopsis of my experience in making the work. The entire project had a level of clarity that I don't think I have achieved elsewhere within a survey of my art. But now I am back to a more tentative state. That's why this body of work in the studio right now really interests me. I think to some extent the kind of experimentation and range that I'm playing with presently has a lot to do with the show at the Haus der Kunst in Munich and the Addison show in Andover. They were two very important shows for me. One presented current work in an interesting context. The other included many of my earlier pieces—a more intimate side of my work. In both exhibitions I reacted to

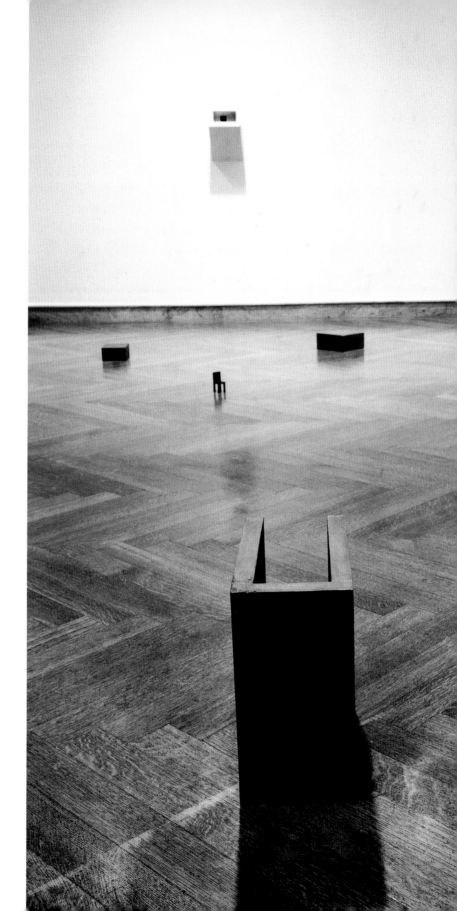

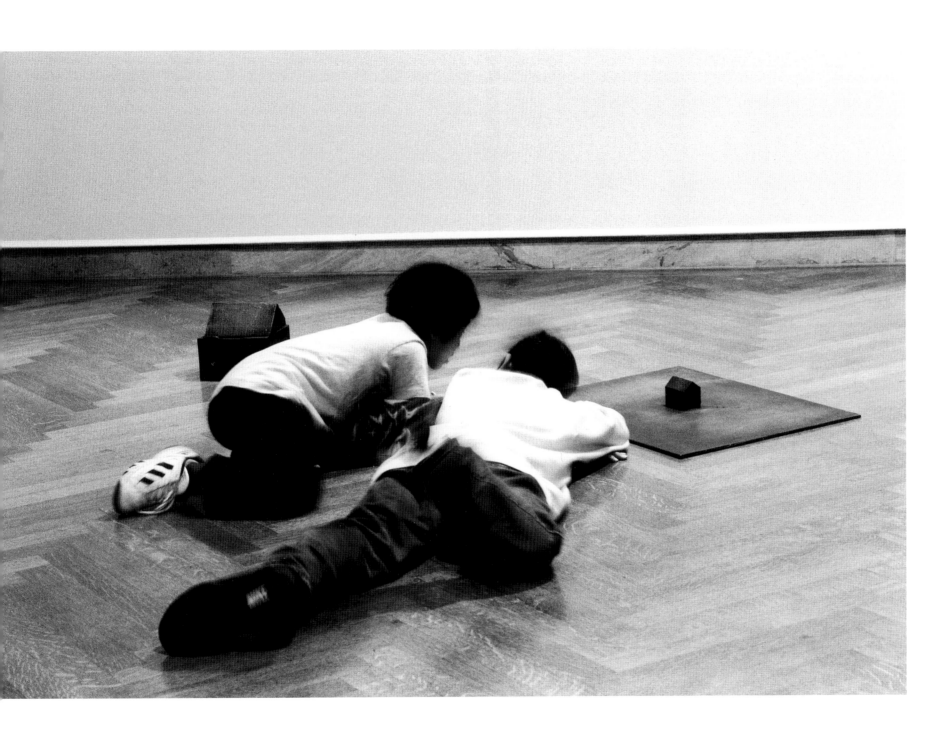

47

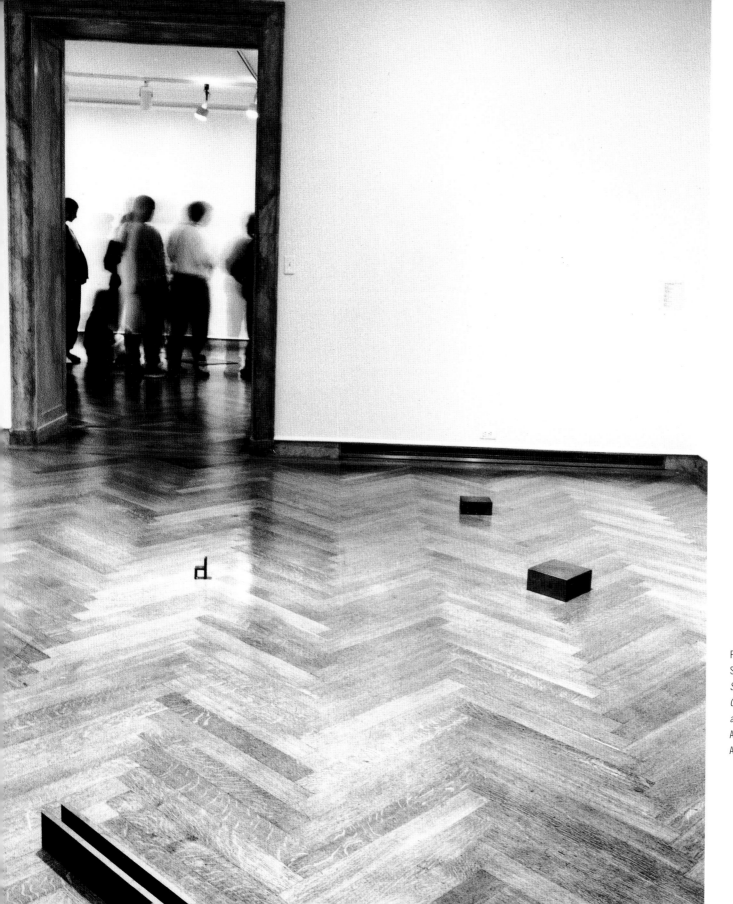

Pages 48 and 49:
Students visiting *Joel
Shapiro: Sculpture in
Clay, Plaster, Wood, Iron,
and Bronze, 1971-1997*,
Addison Gallery of
American Art, fall 1997

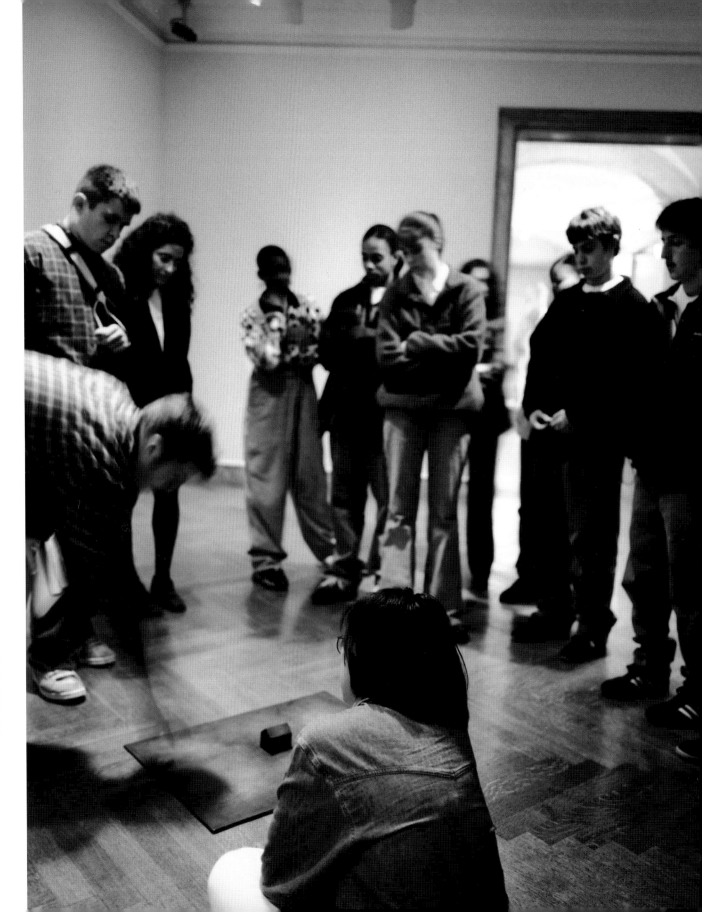

Pages 50 and 51:
Joel Shapiro: Sculpture in
Clay, Plaster, Wood, Iron,
and Bronze, 1971-1997,
Addison Gallery of
American Art, fall 1997

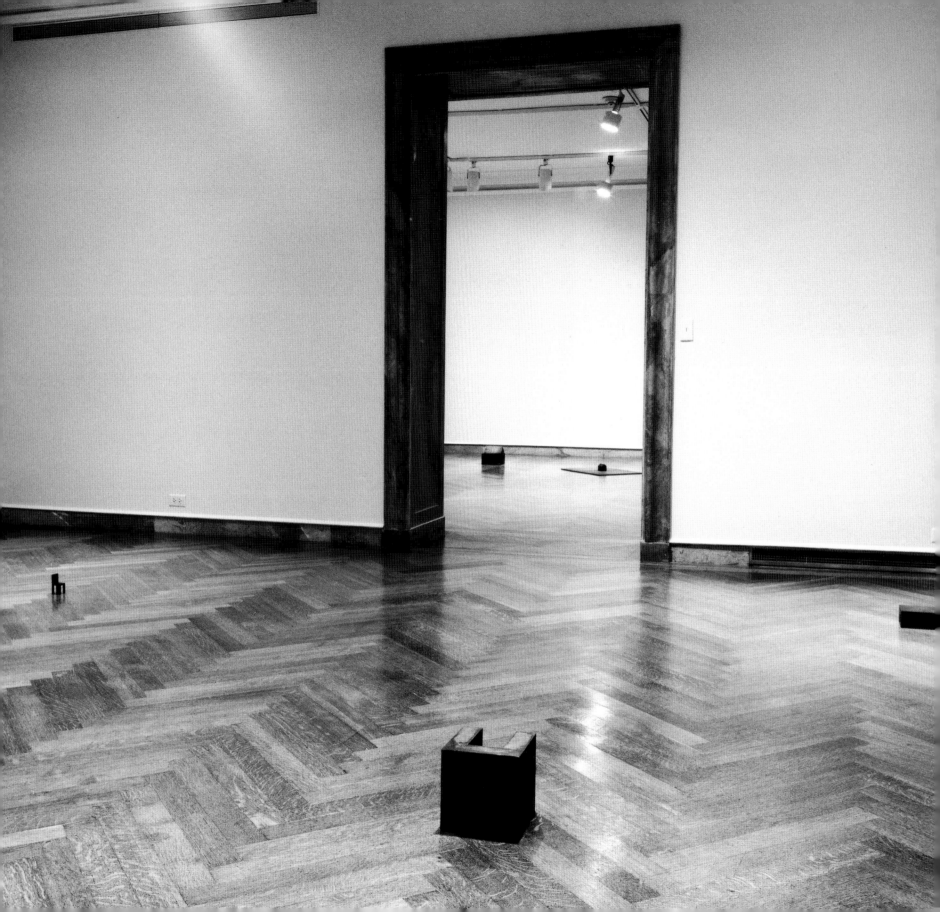

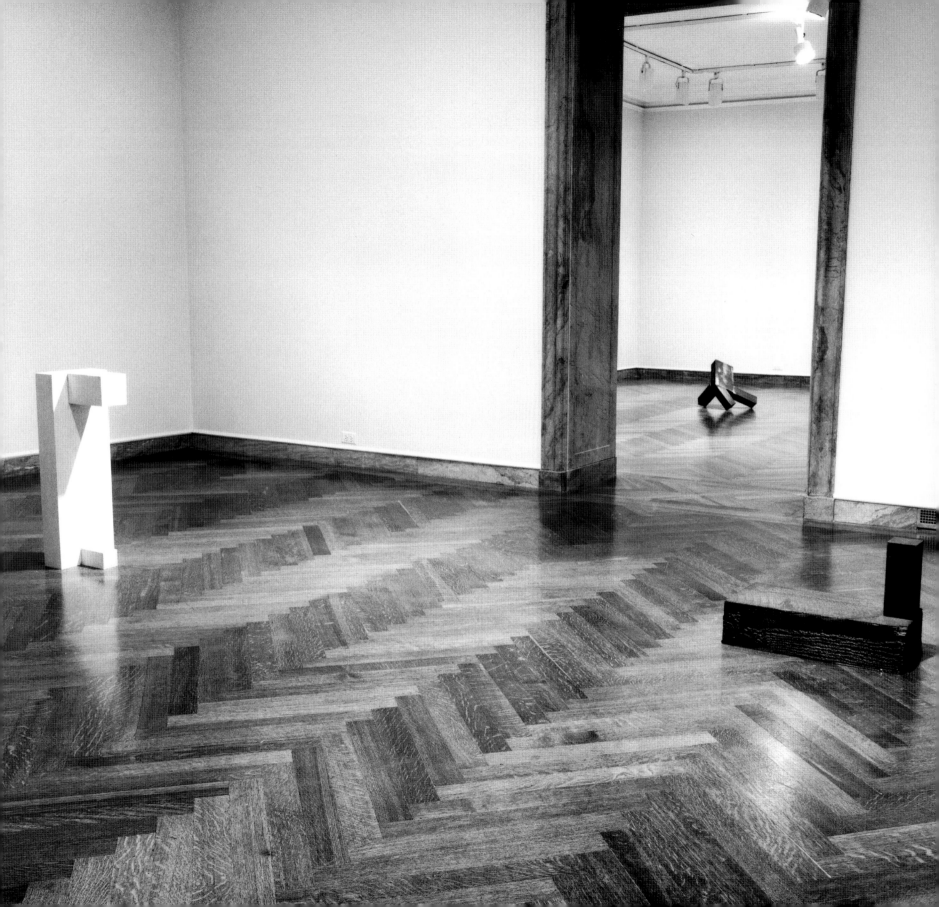

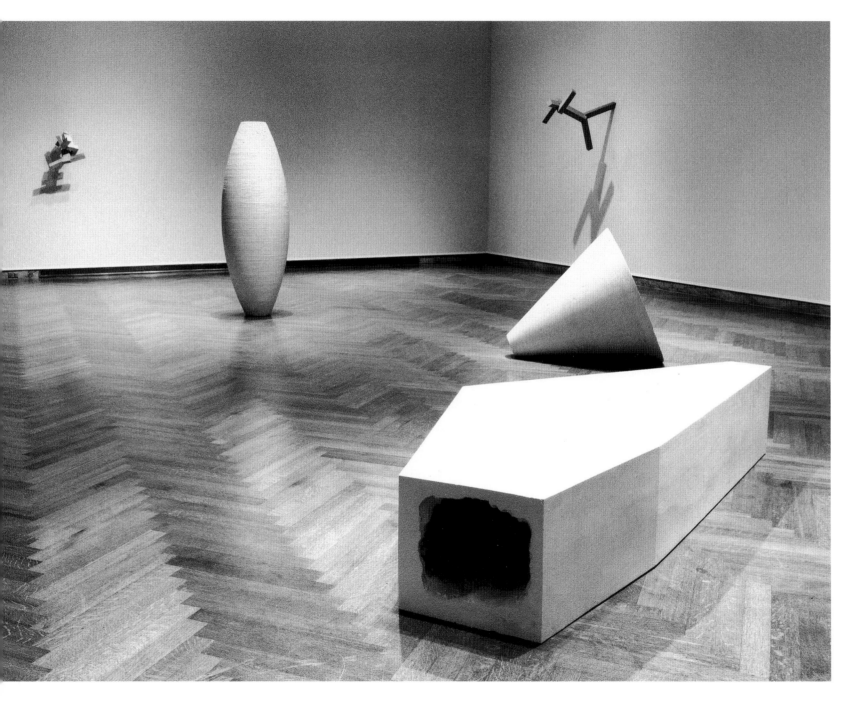

Pages 52-63:
Joel Shapiro: Sculptur
Clay, Plaster, Wood, Ir
and Bronze, 1971-199
Addison Gallery of
American Art, fall 199

52

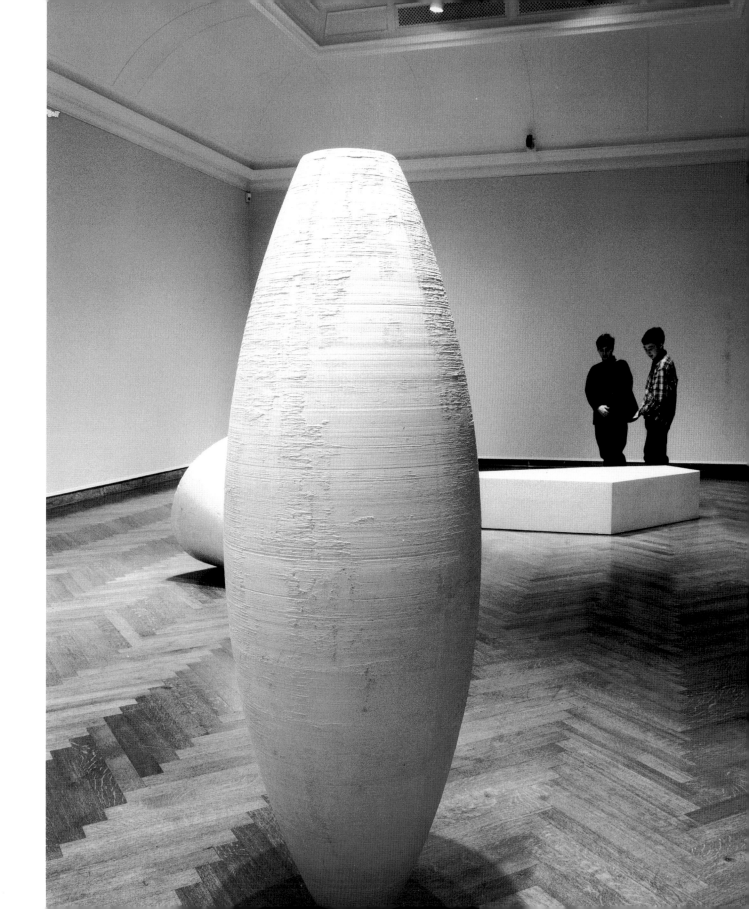

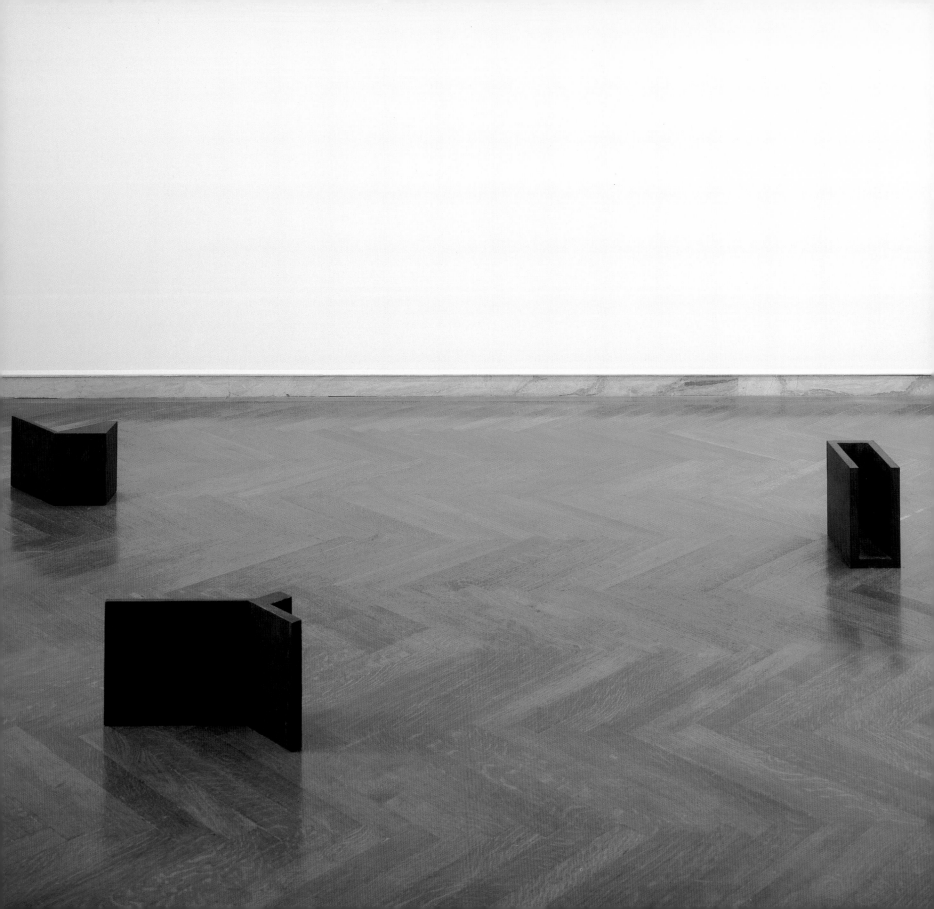

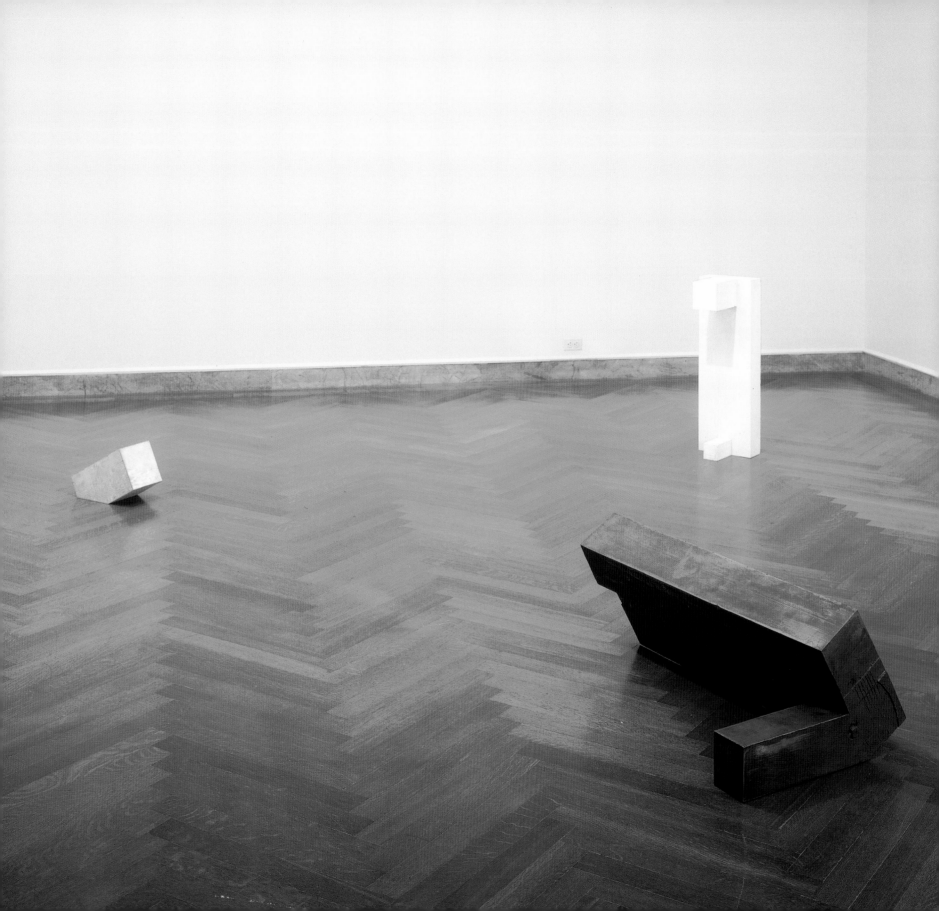

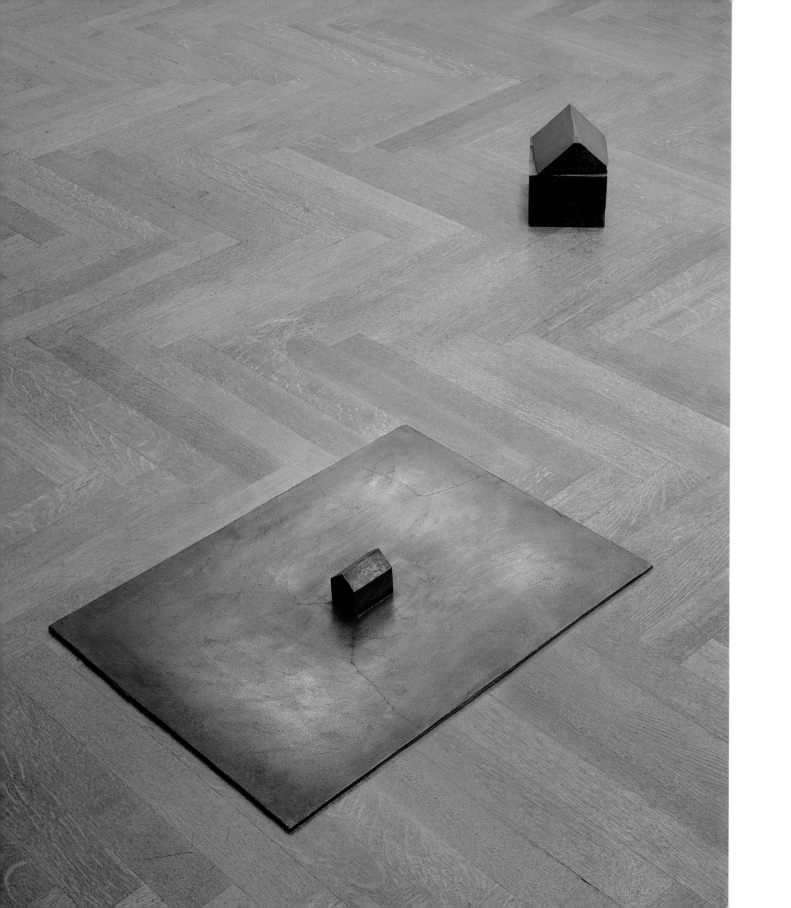

56

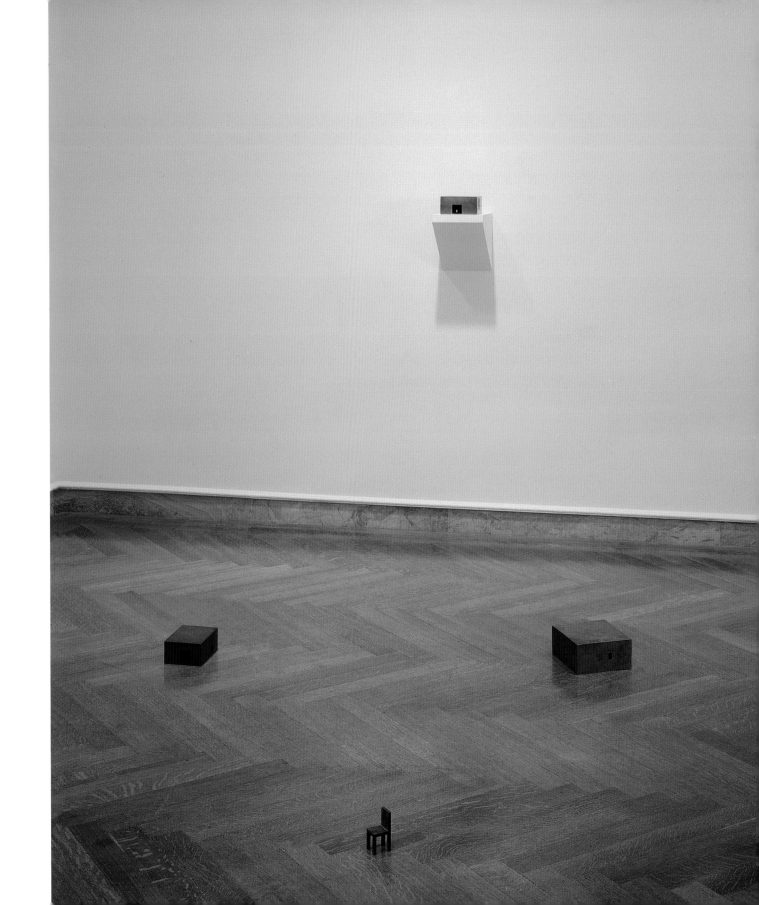

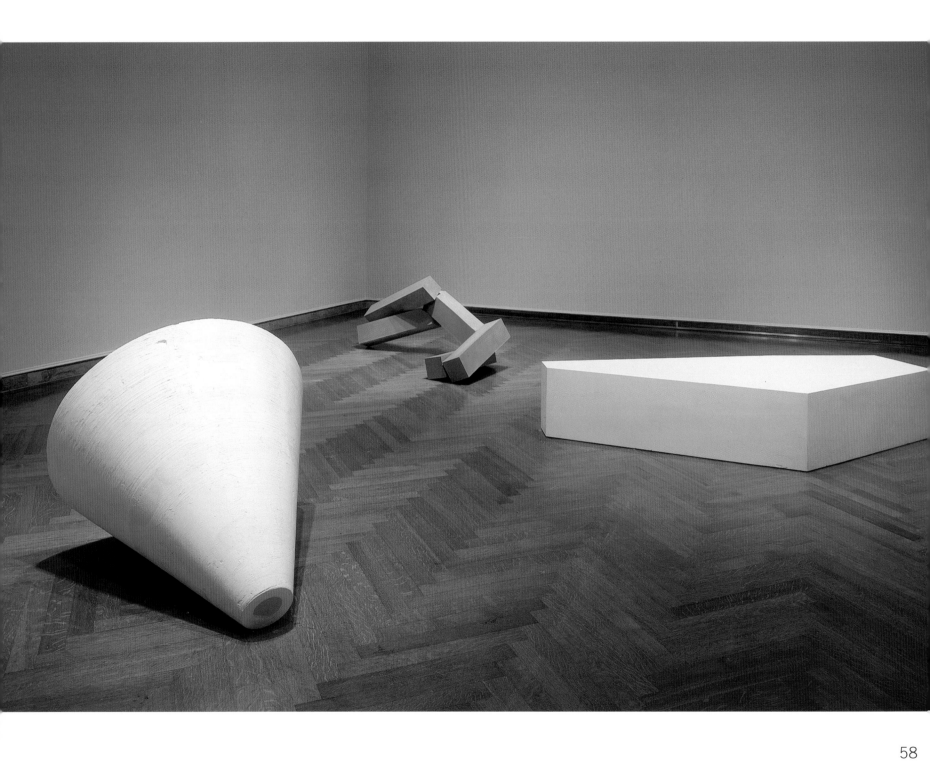

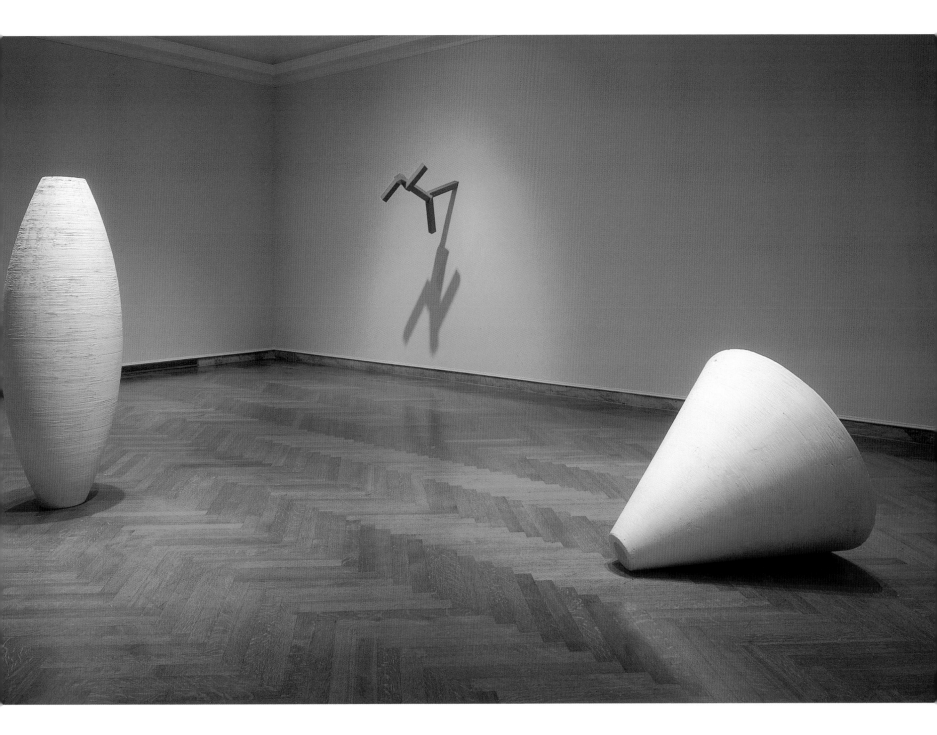

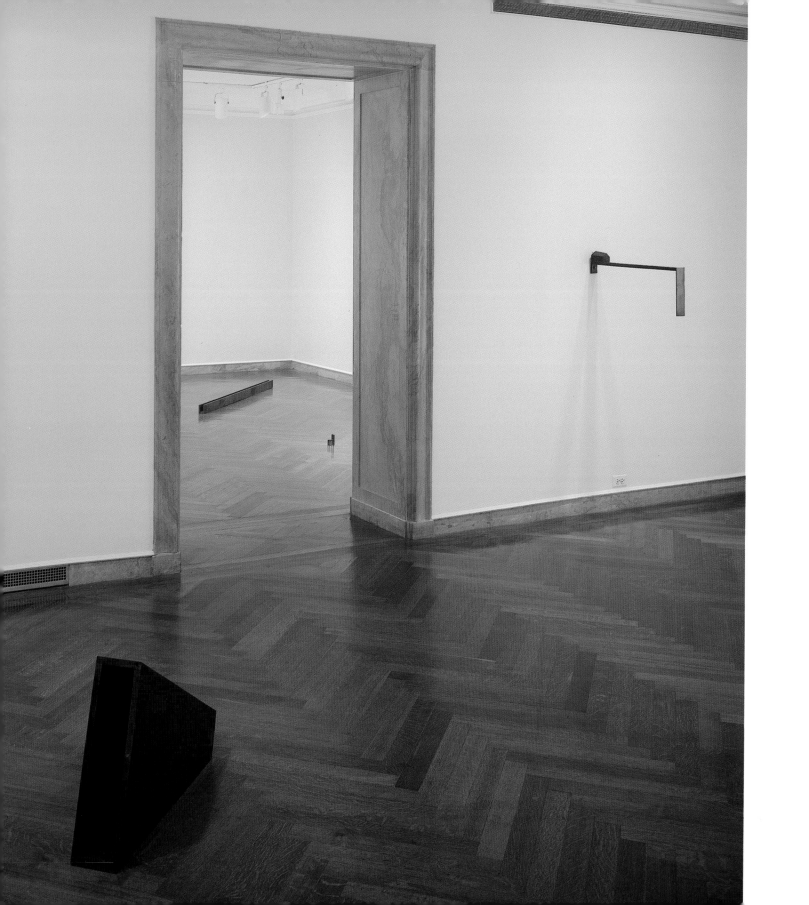

60

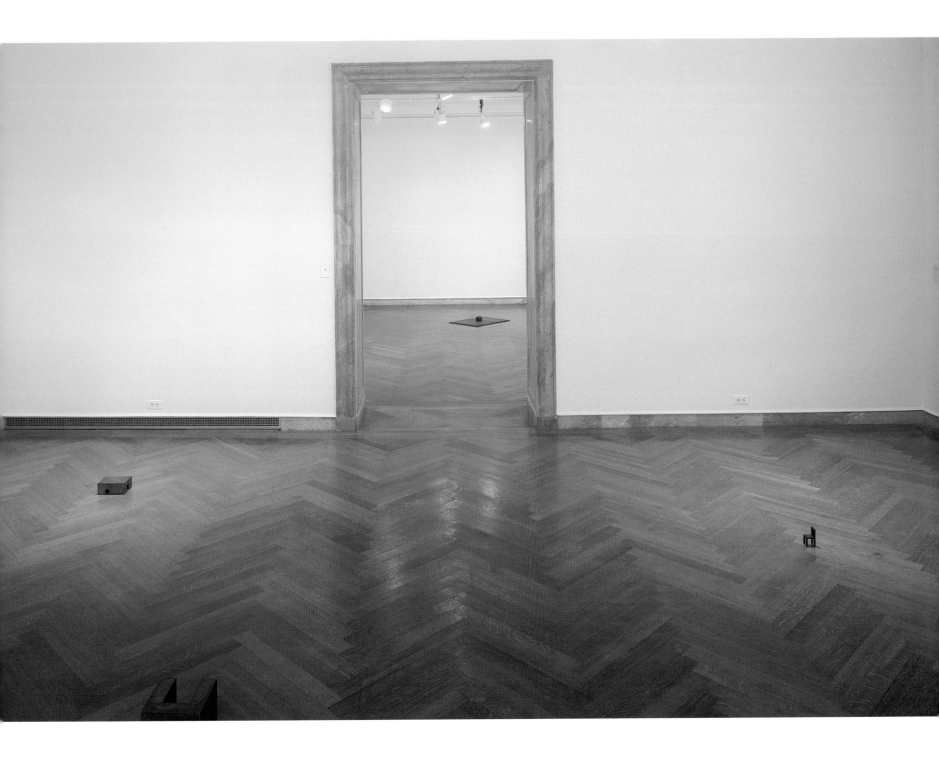

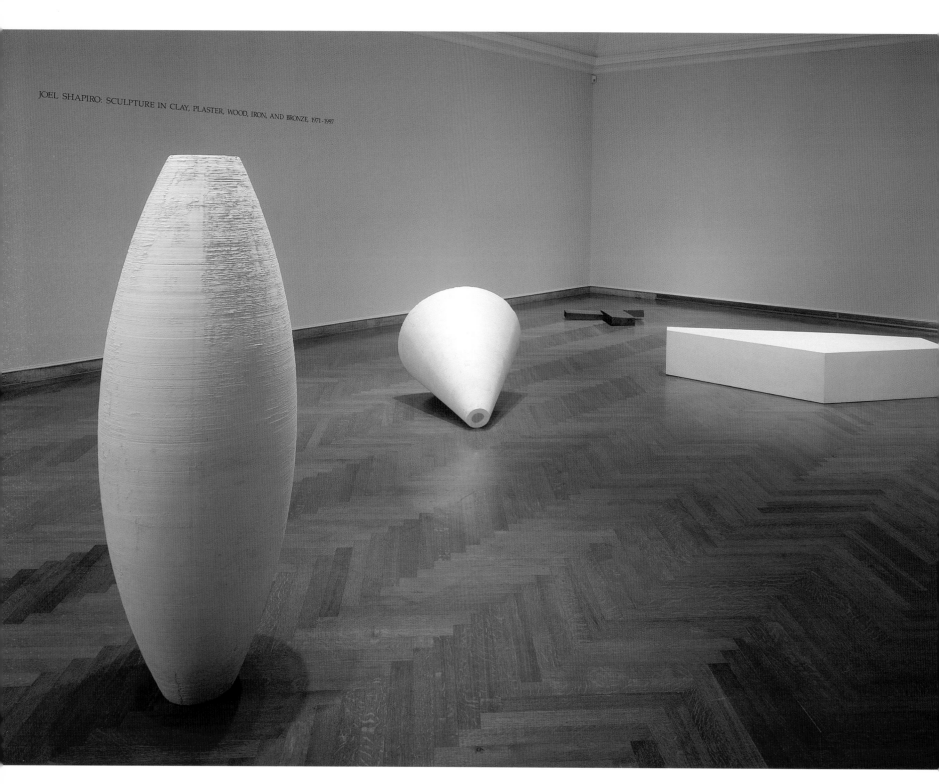

JOEL SHAPIRO: SCULPTURE IN CLAY, PLASTER, WOOD, IRON, AND BRONZE, 1971-1997

62

architecture and tried to dispel conventional notions about my work. The new work I am doing evolved between these shows. The two projects became counter-arguments.

JR: It was interesting to see how you broke away from installing your figurative works only on the floors of rooms in both of these shows. Some figures got mounted directly on the walls, activating rooms and space in a new way. In the Haus der Kunst show this gesture seemed to be rooted in what I surmise was your anxious and somewhat defiant response to the huge scale of the German galleries and the museum's historical baggage as a favored building of the Third Reich. Your large bronzes simply weren't going to behave sedately or politely in that place.

When you introduced four painted wooden figures into the second half of your Addison exhibition—with three figures mounted on the wall and one reclining on the floor in our large gallery— I felt the spatial and emotional nuance of the room was also altered by your use of color and the relationships the new figures had to your large plaster pieces—the half coffin/half house sculpture with its cave-like entrance, the large funnel piece, and the tapered form you nicknamed "the bomb."

When you first arrived on campus last fall, to begin working in our visiting artists' studio, I remember you bringing the pre-cut parts for a large wooden figure into the workspace and laying them out on the floor. You pushed and kicked this disconnected figure around quite nonchalantly for a while. I kept taking notice of it. Then one day you began cutting up various bits of pine and assembling a group of figures that fully animated the walls of the Andover studio. Visiting you now in your New York studio, I'm interested to see how you have taken pre-cut fragments from a large wooden figure and begun to levitate them off the floor, using smaller stick braces to keep a disjointed figurative image hovering in space. What's been going on in your mind as you've worked this way?

JS: It's interesting that I entirely forgot about those cut beams of wood—they kind of embodied everything I hate. They were laying there on the floor in the most passive fashion. I frequently do stuff that ends up as a starting point or summarizes everything I am not interested in, and announces what I have to do. The cut beams were pulled apart so that the individual elements didn't interlock. They had zero kinetic energy since they were resting on the floor. I seem to be focusing on the figure (the image) pulled apart. This is how I feel. Maybe the interesting thing about this work is it represents a mental state, so the body is whole and the mind is fractured, but in the work the mind is singular and the body is fractured. Before making the work, the artist is torn apart and that dispersed state is externalized into the form, and

Right: Stuc
visiting
Shapiro: Scul
in Clay, Pla
Wood, Iron,
Bronze, I
1997, Adc
Gallery of Ame
Art, fall

64

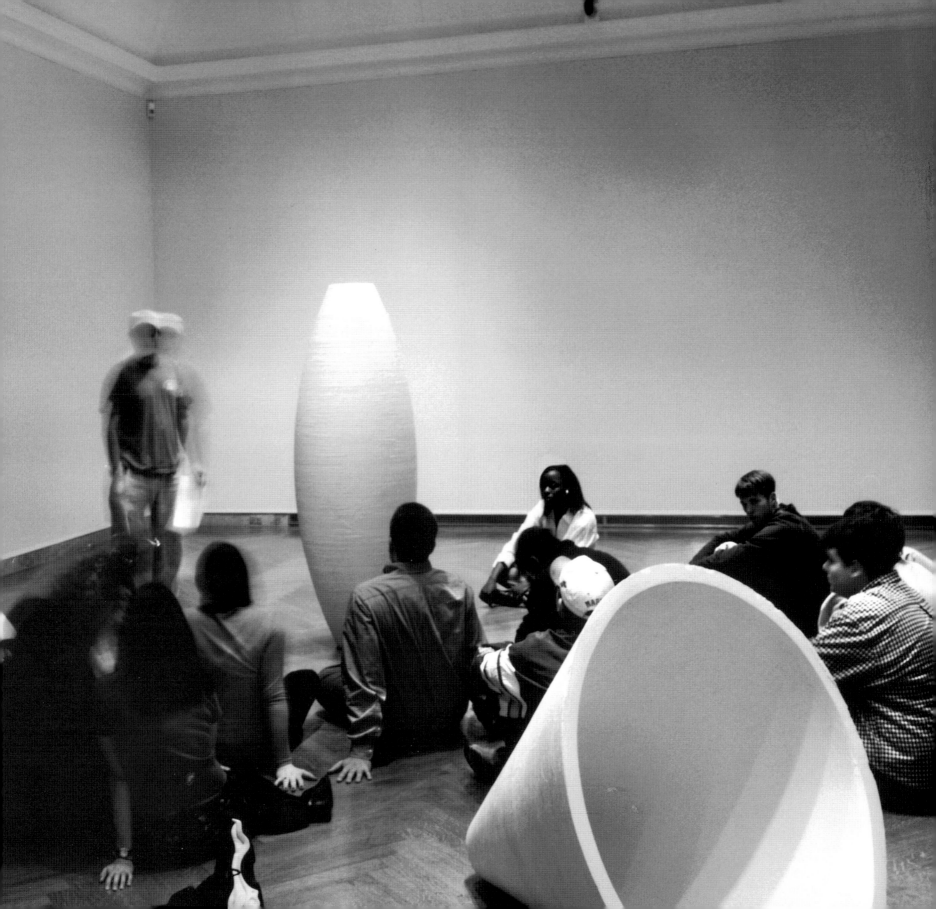

then subsequently there is some mental integration—this sounds like this is the work of a serial killer—all sorts of disjunctive emotional input is externalized into form that creates clarity.

I really couldn't have organized those chunks of wood lying on the floor earlier, the way I am now doing in my studio. I needed to first produce the small painted wood figures I used on the walls at the Addison. By doing so I got off the floor, radicalizing the anchor. I felt that this got the work literally off the ground, into a more imaginative space. I was struggling spatially and emotionally with the mammoth galleries of the Haus der Kunst. There, the sculpture, regardless of how oversized or the amount of conjoining, would not overwhelm the space. It was too grandiose. There, too, I felt compelled to get the work up on the wall and dislocate a predictable point of view.

The problem posed by the stuff lying on the studio floor was its inanimate state. For years I have made vertical pieces that were grounded and anchored, stable in their instability. I was trying to conjoin disparate elements into a whole. I keep talking about my relationship to architecture, and to the floor—this bringing together of elements required a lot of will and generally required that my figures be firmly fastened to the floor—to achieve and hold the dis-balance together. Possibly that was a more traditional model. For a long time I have made sporadic attempts to really dislocate mass from the ground without a stick-figurative model. Now, what seemed so difficult a struggle seems very possible. Now I am beginning to work off the ceiling and wall suspending form.

It is tough to find a more engaging subject than the figure, for the human body is such a remarkable mental and physical construction. This synthesis of mind and body is so pervasive that it seems to overwhelm all subjects. It conditions how we see landscape, experience architecture, understand artifact, and perceive space.

JR: Was there a point in time when you decided to focus more specifically on the human figure and then consciously chose to shed direct references to things like the elemental houses, benches, chairs, and other images you employed in much of your earlier work?

JS: I may have shed some direct references, but I think I continued to deal with the same problem that made those early pieces interesting— the play between the imaginative, fictive world of the maker and the actual experience of the space occupied. I think that's something that I absolutely synthesized into the more figurative work. I think it really had to do with the way any of the planes in my figurative works relates back to architecture. So now you have space that is determined by the interaction of the form and the architecture. Although my forms are geometric, their organization is not determined by the pragmatic necessity

66

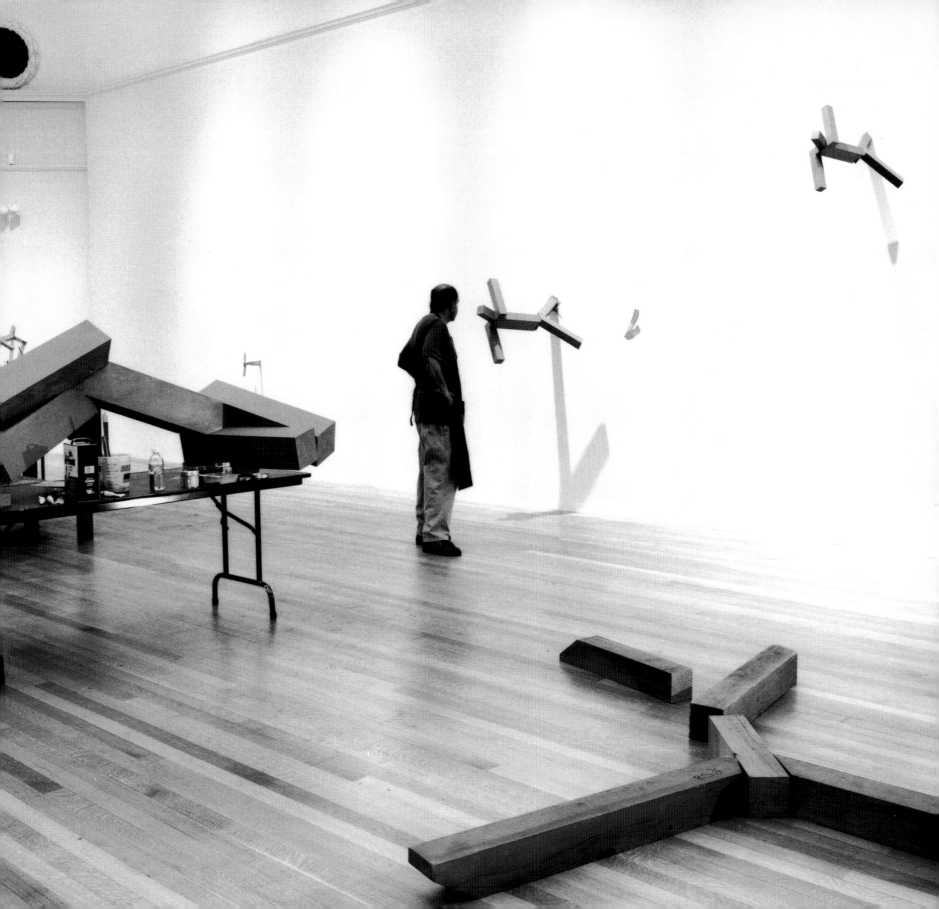

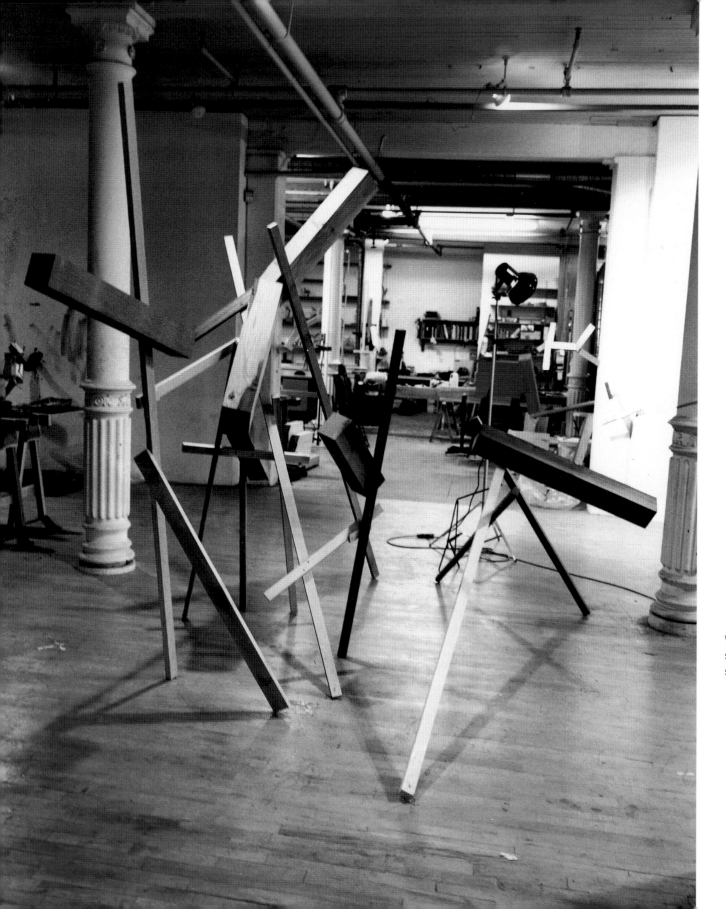

View in Joel Shapiro's
studio, New York,
spring 1998.

of architecture, they are much more about a mental projection and are far more disruptive. It is too easy to dismiss figuration and not deal with its abstract implications. I'm not interested in mimetic figuration. In fact, I'm not interested in mimesis. The only conscious effort I made to change—the one critical problem I saw in my work—was my dependence on architecture as a force in the organization of form. My discomfort was not so much with how the work looked in rooms, but how architecture—not so much architecture but horizontality and perpendicularity—became the genesis for form, and inevitably a huge limitation.

JR: Why does that bother you? Why do you feel ambivalence about that? I always loved the relationships you've created in working this way.

JS: I think that often form is much too conditioned by conventional notions of architecture. It's a real aspect of minimalism that I think is kind of stifling. I felt that what I was much more interested in was projection of personal thought and narrative, a more intimate use of space. When you strive for this you don't have to give up your relationship to architecture. It's just that you must give up the predictability of using it. I mean the problem is to make form that is convincing, more lively, which has independent strength. I wanted that independence from architecture. Not that I was giving up my interest

in architecture, but I did not want architecture to condition the form and to be such a strong determinant. Minimalism accepts horizontality and verticality, it doesn't violate them. Every wall and floor is okay. It seems passive, predicated on convention: the floor, the wall and the furniture. I want the freedom to see, to express images that can co-exist with architecture in other ways. I am trying to talk about a more complicated psychology of form and built forms.

JR: How do you think about architecture in relationship to how you've used images within it, particularly the human figure? I'm thinking of Eadweard Muybridge for a moment, who recorded the human figure in thousands of permutations that could be registered in space and time. His first motion photographs appeared as dark silhouettes because that was what the early technological state of photography allowed for when he began his experiments in California. Years later, in Philadelphia, where Muybridge moved to undertake his mammoth *Animal Locomotion* project, the visual resolution of photographic images became much clearer, and he chose to photograph most of his subjects against the backdrop of a classic Cartesian grid. I've often wondered if that large body of work would have had that same expressive power had it not possessed an incredibly strong and formal relationship to the grid—which provided another way (beyond that of

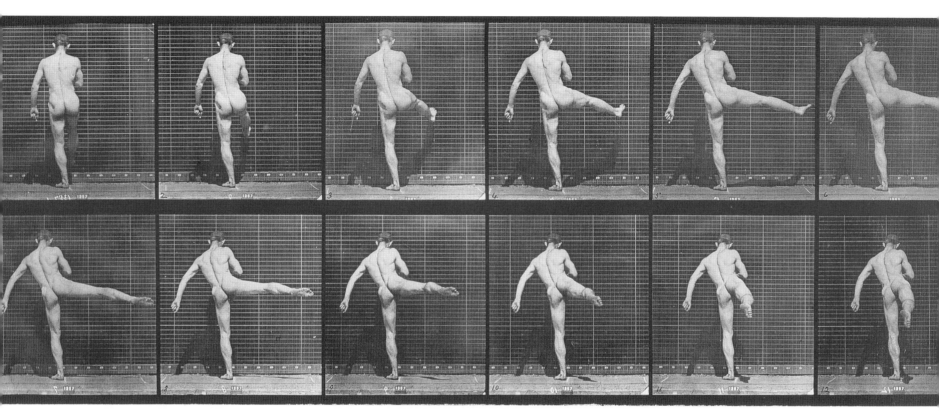

Eadweard Muybridge, *First Ballet Action,* Plate 369 from *Animal Locomotion,* 1887, collotype print, 18 1/8 x 23 1/4 in., Addison Gallery of American Art, Gift of the Edwin J. Beinecke Trust, 1984.6.369.

timed sequences) for Muybridge to observe how the human body can be measured—how its proportions and forms can be revealed.

JS: I think that's true. I was very interested in his work and poured through the books early on. It's interesting the stuff that really engages us, the stuff we end up looking at. With Muybridge you see that if the arm is moving, the body is moving. The arm is moving in relationship to some greater whole. Muybridge created a way to set some fixed point of view that the eye can measure motion against. In this new piece, I am using dispersed elements that are supported by a very loose lattice (grid) that is determined by the location of the piece in space. Basically, I grab a piece of wood and support it with sticks that are lying around the studio. This is a way of organizing separate elements, and the lattice becomes a trace of where, and, more importantly, how, I put the element into space. Inevitably, the lattice itself has a figurative aspect—a kind of secondary figuration. Basically the lattice becomes a complicated matrix in which the disparate pieces come together through viewing.

Checklist for September 20, 1997 installation

Untitled, c. 1971
Clay
Collection of the artist
JS1241

Pariscraft #2, 1971
Plaster and gauze
Collection of the artist
JS28

Untitled, 1973-74
Cast iron
edition: 0/2
Collection of the artist
JS64

Untitled, 1974
Bronze
edition: 0/3
Collection of Ellen Phelan
JS83

Untitled, 1975
Bronze
Collection of Ivy Shapiro
JS113A

Untitled, 1975
Cast iron
edition: A.P.
Collection of the artist
JS114

Untitled, 1976
Bronze
edition: A.P.
Collection of the artist
JS151

Untitled, 1978
Bronze
edition: A.P.
Collection of the artist
JS226

Untitled, 1979
Cast iron, milled
Collection of the artist
JS322

Untitled, 1982-83
Cast iron
edition: A.P.
Collection of the artist
JS498

Untitled, 1982-83
Cast iron
unique
Collection of the artist
JS499

Untitled, 1984
Cast iron
edition: 0/1
Collection of the artist
JS587

Untitled, 1984
Cast iron
edition: A.P.
Collection of the artist
JS588

Untitled, 1983-84
Cast iron
Collection of the artist
JS589

Untitled, 1984-88
Bronze
unique
Collection of the artist
JS591

Untitled, 1983-84
Plaster
edition: A.P.
Collection of the artist
JS599

Untitled, 1984-85
Plaster
edition: 2/2
Collection of the artist
JS627

Untitled, 1992
Plaster cast
Collection of the artist
JS788B

Untitled, c. 1981
Plaster
Collection of the artist
JS1003

Untitled, 1992
Bronze
edition: 0/1
Collection of Ivy Shapiro
JS1220

Untitled (large coffin), 1993-94
Plaster
Collection of the artist
JS1242

Untitled, n.d.
Wood and paint
Collection of the artist
JS1246

Checklist for November 4, 1997 installation

Untitled, 1973-74
Cast iron
edition: 0/2
Collection of the artist
JS64

Untitled, 1974
Bronze
edition: 0/3
Collection of Ellen Phelan
JS83

Untitled, 1975
Bronze
Collection of Ivy Shapiro
JS113A

Untitled, 1975
Cast iron
edition: A.P.
Collection of the artist
JS114

Untitled, 1976
Bronze
edition: A.P.
Collection of the artist
JS151

Untitled, 1979
Cast iron, milled
Collection of the artist
JS322

Untitled, 1982-83
Cast iron
unique
Collection of the artist
JS499

Untitled, 1984
Cast iron
edition: 0/1
Collection of the artist
JS587

Untitled, 1983-84
Cast iron
Collection of the artist
JS589

Untitled, 1984-88
Bronze
unique
Collection of the artist
JS591

Untitled, 1983-84
Plaster
edition: A.P.
Collection of the artist
JS599

Untitled, 1984-85
Plaster
edition: 2/2
Collection of the artist
JS627

Untitled, 1992
Plaster cast
Collection of the artist
JS788B

Untitled, 1992
Bronze
edition: 0/1
Collection of Ivy Shapiro
JS1220

Untitled (large coffin), 1993-94
Plaster
Collection of the artist
JS1242

Untitled, 1997
Wood
Collection of the artist

Untitled, 1997
Wood
Collection of the artist

Untitled, 1997
Wood
Collection of the artist

Untitled, 1975
Cast iron
edition: 2/2
Collection of the artist
JS115

Untitled, 1975
Cast iron
edition: A.P.
Collection of the artist
JS141

Chasm, 1976
Cast iron
edition: A.P.
Collection of the artist
JS148

Untitled, 1977
Bronze
edition: 2/3
Collection of the artist
JS188

Untitled, 1981
Cast plaster
Collection of the artist
JS447

Untitled, 1981
Cast plaster
Collection of the artist
JS448

Untitled, 1983-84
Plaster
edition: A.P.
Collection of the artist
JS599

Untitled, 1984-88
Bronze
unique
Collection of the artist
JS591

Untitled, 1989
Cast iron
unique
Collection of Ivy Shapiro
JS916

Untitled, 1985
Iron
Collection of the artist
JS921

Untitled, n.d.
Plaster
Collection of the artist
JS1243

Untitled, n.d.
Bronze
Collection of the artist
JS1244

Right: View i
Sha
studio, New
spring

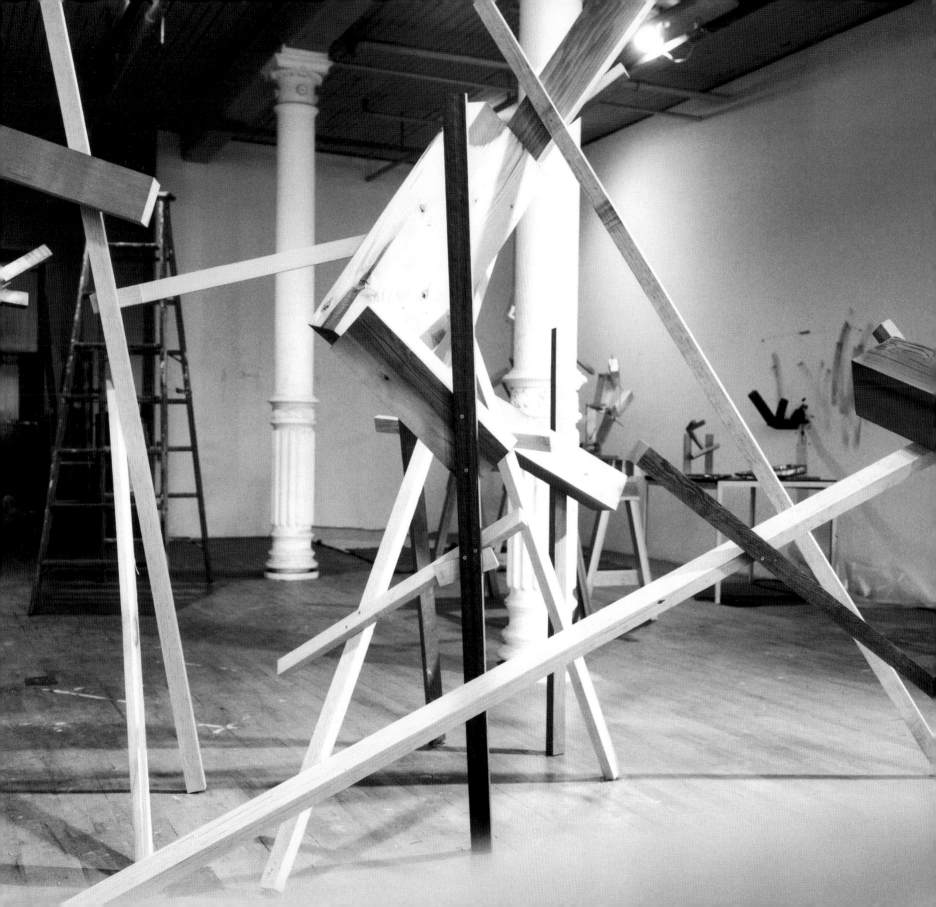

Joel Shapiro

Lecture at Harvard University
September 18, 1997
Edited by Pamela Franks

Ellen Phelan:

Introduction

HELLO. HELLO, AGAIN. WELCOME TO THE CARPENTER CENTER. I am Ellen Phelan, director of the Carpenter Center, and since I've been introducing these things for the last couple of years, I think, if you've been here before, you know I've developed a particular introductory style, since I'm trying not to do what I think of as the general obituary for these artists. I try to come with something a little more personal or say what I think about their work. And, of course, the recipients of these encomiums of mine tend to have one of two reactions. Either, if I get it right, they start to say, "Oh, my God, she stole my speech. Now what am I going to talk about?" Or else they say, "Where did she get that crazy idea about my work?"

I think that, as you probably know, most of the people who come here to talk are artists whom I admire a great deal and who also are my friends to some extent. And in this case, friendship goes even deeper because Joel and I have been together for 25 years, you know, and I must say that in my long exile up here in Cambridge, one of the things I miss a great deal, and that I've become acutely aware of when I go home and we're together, is how much we actually talk about art. We talk about our friends, and we gossip, and we talk about world problems, but most of the time we talk about art. And I must say, this has been pretty much the case for the last 25 years. So it's a conversation I enjoy a lot and miss.

It's very hard for me to be objective about his work, but I would say that overall he's a classicist. And most importantly for our times, he's a humanist. And he's become very clearly that. He also has a tremendous range in his work by this time of formal options and choices. I think he usually doesn't talk about that part of it. He talks more about the emotional content. But I'm often amazed at his fluidity with choices in work. I tend to be kind of the romantic one—I tend to be more interested in the ephemeral nature of perception. And he likes to deal with the reconciliation of opposites and synthesis.

I think the work more recently, which would be over the last 15 years time, has—and this is the figurative work—particularly become quite brilliantly involved with multiple readings and reversals which in the two-dimensional painting world would probably be the equivalent of figure-ground equivocation or reversal. I think this gives tremendous animation to the work. I sometimes wonder if this is related to early experiences with sculpture with multiple limbs in India when he was in the Peace Corps. But I think that that's probably true only in the most refined and abstract way.

As two working artists, having studio conversations, I will quite frequently drag him to my studio and ask him if something is finished. And when he is working with polychrome, he'll often ask me about a color. What would be a cold lonely color, or what would be a distant but erotic color? And then we both ignore each other's advice and go on.

Please join me in welcoming Joel Shapiro.

I'VE BEEN MEETING WITH STUDENTS for the

last two days, trying to address certain

problems that I have confronted and continue

to confront as an artist, including how one can

believe in the work one makes, and various

other issues and ideas that interest me.

Today, I thought I would discuss work from

1969 on and continue this line of questioning.

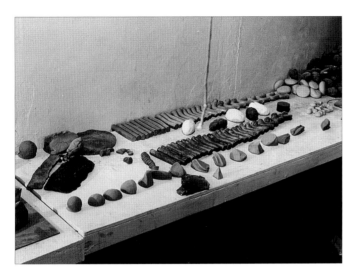

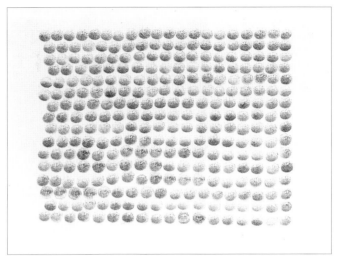

I took this photograph in my studio in 1970, of work that
I did in 1969 and 1970. Before this I was doing work that
was based on a rational external idea to create definite form.
Around this time, I decided to make things with my hands and
manipulate material, to investigate material. I would hammer
pieces of metal and manipulate pieces of clay and flatten
things. Generally I used simple materials and only very
elementary tools. The shape of the work was determined by
the process. I was also thinking about size and scale; this
work was often hand-sized. I didn't think of this process as
sculpture or not as sculpture. I thought of the work that
resulted more as artifact, because it was about marking time
and accumulation.

Around this time, I addressed similar issues in drawing as
well. I used a stamp pad and made ink finger prints. There
were several of these drawings, the smallest was probably
12 x 10 inches. Some were really large; I wouldn't say they
were large and aggressive, but they did get bigger, up to
12 x 8 feet with thousands of marks. They were about
marking time and trying to relinquish a certain amount of
responsibility for the finished image. The drawing is the
result of the process.

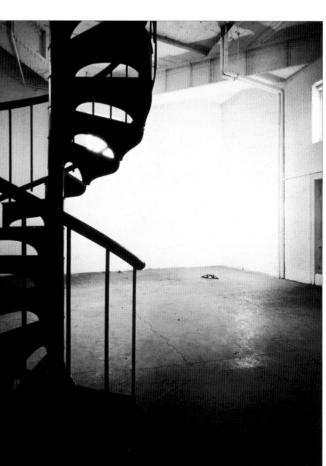

Bridge, 1973, Milled grey cast iron, 3-1/2 x 22-1/2 x 3 in.

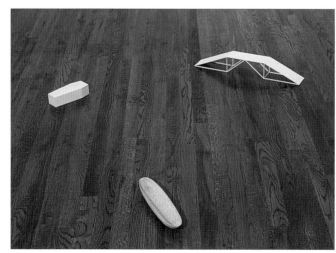

Two Hands Forming, 1971, Fired clay, 93 units, 3 in. diameter each (foreground), and *One Hand Forming,* 1971, Fired clay, 77 units, 1-1/2 in. diameter x 3-1/2 in. each (background).

Two sculptures from 1971 consist of piles of clay. One group I made with one hand, and I called it *One Hand Forming.* The other I made with two hands, called it *Two Hands Forming,* and just kept making elements and putting them on the floor as I made them, until I lost interest. At some point, there's nothing else to do. I was talking to students about how you have to have a certain amount of confidence—enough confidence really to just leave a work as it is. I think it is critical that the artist somehow reveals his anxiety about the work, *in the work,* otherwise it is easy to confuse making art with making finished objects of no real interest.

Bridge, 1973, Milled grey cast iron, 3-1/2 x 22-1/2 x 3 in., installed in the exhibition *Joel Shapiro* at The Clocktower, Institute for Art and Urban Resources, New York, April 12-April 28, 197

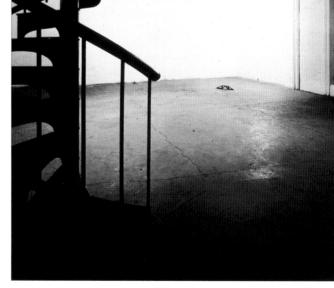

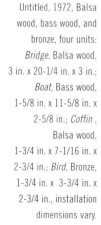

Untitled, 1972, Balsa wood, bass wood, and bronze, four units: *Bridge,* Balsa wood, 3 in. x 20-1/4 in. x 3 in.; *Boat,* Bass wood, 1-5/8 in. x 11-5/8 in. x 2-5/8 in.; *Coffin ,* Balsa wood, 1-3/4 in. x 7-1/16 in. x 2-3/4 in.; *Bird,* Bronze, 1-3/4 in. x 3-3/4 in. x 2-3/4 in., installation dimensions vary.

In 1972, I made a piece that consisted of a small coffin, a small boat, a bridge made out of balsa wood, and a small bronze bird. I eventually reached a point in my investigations of process and material and scale at which it was inevitable that I allow imagery into the work. And there was also the question of showing the work in public. I wanted to keep the same sort of measure I had in my studio, but externalize it. In 1973 I made a cast iron piece using the same image of the bridge. I machined this bridge out of a block of iron so the piece was carved. It was 22 inches long. I showed it at The Clocktower, which was one of the early alternative exhibition spaces, and it actually was the first show there, so the expectations associated with the space were minimal. I showed this 22-inch iron bridge in a large room with a big spiral staircase. The piece had a very strong presence, and the effect of scale when you walked into the room was pronounced. The piece was small and insistent, and the space it was in was large. It wasn't until recently that I actually began to work fairly large, making a piece larger for a context other than my studio, altering the size from the size I wanted in my studio.

Untitled, 1973-74, Cast iron, 3-5/16 x 1-13/32 x 1-11/16 in.

This small chair is 3 x 1 1/4 x 1 3/4 inches. Again, I made this piece in my studio, the size I wanted in my studio. And when I made it, it seemed to be about loneliness. It was theatrical. I was aware of the drama at the time, although when I made it, it was real. And if I had made it into a full-sized chair and exhibited it, it would have been meaningless. I didn't invent the chair and I was definitely not the first person to use the chair in art. There was plenty of chair imagery going around. The potency of this one was possibly because it was so small. When installed properly, it condenses space. It has a way of contracting the space around it and drawing that space down into the small object. The effect occurs because the chair (and normal chair size) is a common point of reference.

Untitled, 1973,
Enamel on wood,
6-1/2 x 6-1/2 x 1-1/8 in.

Untitled, 1974-75, Cas
iron, 5-1/4 x 10 x 9-3/

A small wall relief from the same period depicts a guy riding
backwards on a horse. I was interested in American Indian
imagery and I took ideas from paintings and synthesized this
image. You can always find a source or what something means
to somebody. I was not terribly content with the piece, so I
took a can of spray paint, and sprayed the sculpture on the
wall, as a means of integrating it into the wall and sort of
obscuring the image. This small horse relief was part of a
show that also included a small bronze horse, and the chair,
installed in the louvers of the Paula Cooper Gallery, which
was a large gallery in SoHo. It was a very effective show. I
think scale was the key to what this work meant to me, and
what it might mean, or how somebody else who didn't make
the work might perceive it.

A cast-iron sculpture from 1975, which I unfortunately
destroyed, was defensive and guarded. In order to experience
this work, you would have to mentally enter its interior space.
The work is obdurate and massive, about 150 pounds of iron
enclosing an interior chamber that one could never really
access, but with two apertures nonetheless. I did a number
of similar pieces and I didn't think of them as houses so much
as rooms, where I contained spaces that the viewer could only
enter mentally via projection. Why did I destroy this piece?
I began to finish the piece and make it look good. In the end,
though, it got too tuned-up, and I just left it in the machine
shop and used it as a support for drilling. I just left it
because I had basically already destroyed the piece by
overworking it, and not having enough faith in my intuition
and my instinct to stop.

Untitled, 1976-77,
Oil on bronze,
Edition of 7, 9-3/4 x
2-3/4 x 5-3/4 in.

Untitled, 1977, Bronze,
x 15-11/16 x 2-1/4 in.

In a cast-iron work from 1977, my impulse to cast was partly in order to integrate four pieces of wood and solidify them into one unit. The resulting piece was very heavy and dense and was exhibited as part of a series of wall reliefs. I worked in other materials as well for these wall reliefs including plaster, which was easier and faster. With this series, I explored issues of negative and positive space, and I found that by varying the thickness conscribed by a single form, I could animate the surface in terms of depth from the wall rather than in terms of full figuration. And I was simultaneously working on explicitly figural works. I did this stiff painted figure in response to a commission from the Modern Art Museum of Fort Worth. But I pursued both veins. This period of my work was about figuration and abstraction, about refiguring abstraction.

Untitled, 1977-78,
Bronze,
3-1/2 x 29 x 21-1/2 in.

I did lots of houses and work that used architectural reference. They were very small, so you would basically look at them and have to enter their world. They would insist on being dealt with on their own terms; otherwise, you would just pass them by. I was very involved with magical thinking. Then I started to want to make work that functioned more in ambient space, the space people normally occupy. I was ready to move on, and intent on getting rid of what I was starting to think of as the juvenile psychology of the prior pieces. With the earlier small pieces, there was no need to see a work in the round to read it as a sign; in some ways this was a defensive pose. In one sculpture, I isolated the house in a pictorial field. I think it is a successful, effective piece, but possibly not as interesting as having a house on the floor in the middle of the room. I was beginning to break up the space and deal with negative space. The problem with this work for me was its relationship to the floor. The floor, like the wall in the case of the reliefs, became such a determinant of the work and the way I was working, because instead of working with real abandon in space, I was conditioned by architecture. This is something that I've continually struggled with in my work. I was starting to want the work to function in the round, independent of the room and independent of the perpendicularity of architecture.

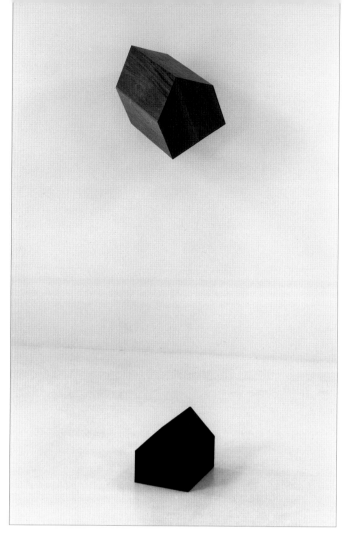

Untitled, 1996-97, Cas
iron and wood, Edition
of 2, iron: 10-3/4 x 13-
1/4 x 10-1/4 in., wood:
31 x 29-1/4 x 31-3/4 i

But nothing goes away, you recycle things, they reappear. The house is back (two times) in a piece from 1997. The cast iron element I did in 1985: it was one of many houses from that year that I was making and burning, and this is one I cast but never burned; then I did this floating, very light wooden house and combined the two into one piece. It came about when a museum in San Francisco wanted to borrow the house from another sculpture, they wanted to split a sculpture in half, because the show was about the icon and common iconography. I didn't want to split the work up. I made this house out of wood, but then I found this iron piece in the basement and put them together. Then the curator of the show did not want this piece because it complicated his notion of the icon.

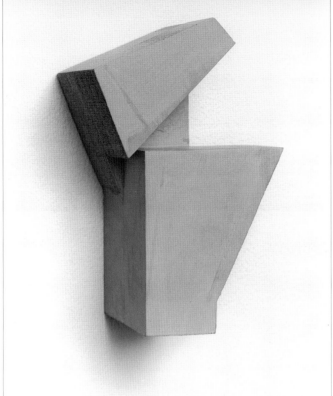

Untitled, 1979,
Wood and gouache,
/2 x 5-3/8 x 3-1/4 in.

Untitled, 1979,
od and white primer,
9-1/2 x 3 x 7 in.

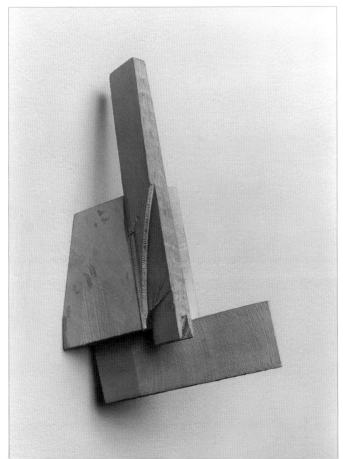

Untitled, n.d.,
Charcoal and gouache,
17-1/2 x 21 in.

I think that my work has been a way of achieving some degree of freedom and playfulness. Again, go back to the wall. I did a series of painted wall pieces in the late 1970s. Some are more dependent on the wall, such as this one, in a way similar to my early drawing which often suggested the folding in of the boundaries on the page. This relief of a year later is much freer and less dependent on the wall, and kind of reverses the space in front of the wall or connects to ambient space rather than being constructed self sufficiently. In a drawing from the same period I was basically finding an image and I needed color, and I wanted the color to refer outside of the drawing, to something else. In fact, I was looking at color in nature: moss, rocks. I had no set intended effect, I would just choose a color that I liked, and that did not correspond to the shape, and then paint that color, so it referred not to the page, not to the drawing, but some other experience or combination of experiences.

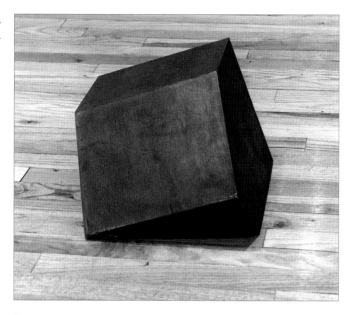

Untitled, 1980, Bronze,
8-5/8 x 12 x 12-1/4 in..

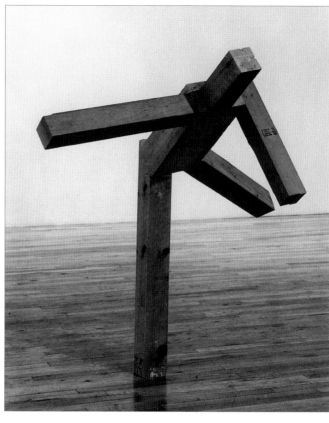

Untitled, 1980, Wood
52-7/8 x 64 x 45-1/2

This piece from 1980 is cast bronze; I thought of these pieces as heads, as sort of self-portraits. Nobody else does. They are always referred to in terms of a house, but I never quite saw that. I built these pieces in the negative. I built plywood molds and then cast into the plywood molds, so the piece was predetermined in the negative, so it had a very insistent geometry and that the surface of the piece would refer back to the plywood that made the piece, rather than out from the core of the piece.

At this point, something happened, I had some real sense of elation, and I began to work larger. Smallness was no longer viable for me. So this is a larger piece, worked with 4-by-4s slapped together to make the figure. I wanted the pieces not to function as a sign anymore, but actually to function literally in space. It was a kind of maturation point in my work. Of course, some people abandoned my work when I made this shift. They find the early work more thoughtful and psychologically compelling. But I think those same qualities are also synthesized into my later work. The accusation against Giacometti—not that I am equating myself because I think he is a much greater artist—was that the early surreal psychological work was the great work, and the later figurative work, because of its verticality, did not have the same viability and brilliance. But I don't think this is true at all, I don't think that Giacometti's later work lost its psychological edge. If anything, I think the later works are more psychological. The early surreal aspect was infused into the modeling of the later pieces.

84

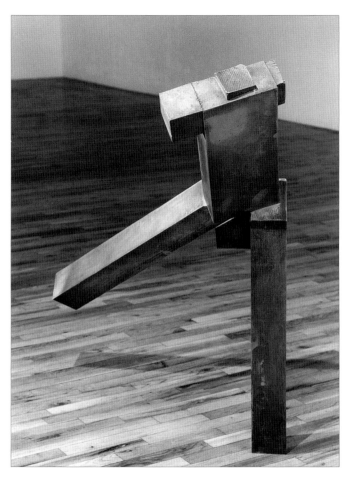

Untitled, 1982,
Bronze, Edition of 3,
43 x 34 x 35-3/4 in.

This is a 5-foot tall bronze. I made the original form in wood, which I chopped and inverted and basically tried to destroy the image. I was and still am very uncomfortable with figuration. I am probably equally uncomfortable with architectural reference. Today, as I was talking to students, I was thinking that Minimalism is as dependent on architecture as academic figuration is on the figure. In both cases, I'm opposed.

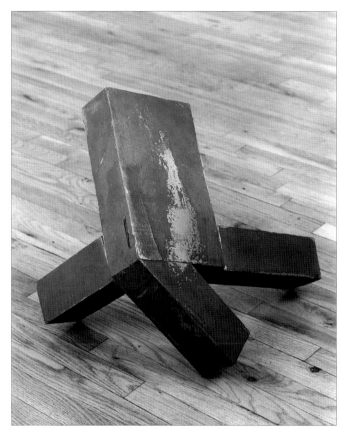

Untitled, 1982-83,
Bronze, Edition of 3,
17-1/4 x 18-1/2 x 16-3/4 in.

This piece is solid cast iron, about 15 inches tall, and I'd say 155 pounds. I describe these pieces with weight because I think the massiveness and the solidity are essential to reading the sculpture. It's massive and solid, and it's a fragment. It is figurative fragments, and it's a sort of geometry. It's an attempt to dislocate and disrupt geometry.

Another concern I have had was how to make large sculpture that is not colossal. Not grandiose and not fascistic or authoritarian. It's a difficult problem. I thought one way to do it is to double up and stack up, like totems might be, rather than make something that is 10 or 20 feet tall.

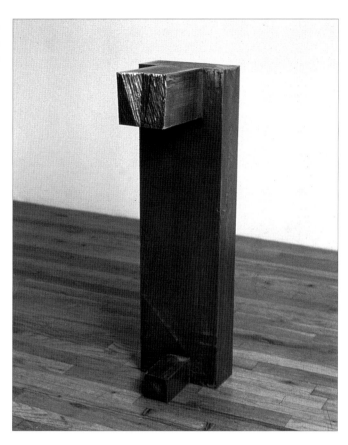

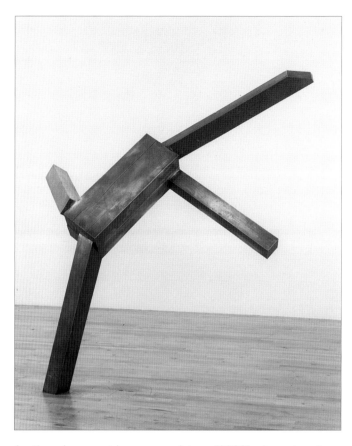

This is sort of memory lane—it is embarrassing. Whatever I'm saying probably has nothing to do with what the work is really about, it may be just some verbal defense; I'm sure it has something to do with it. This piece from 1983 is about 3 feet tall and, it's really about, I mean, what is this piece about? Is it about self-reflection? Somebody looking at their genitals? I think that's partly what the piece is about. It's great stuff. I love this piece. It's really about some sort of narcissism, self-reflection, pondering.

Another piece, cast iron, same vintage (1983), shows how I was trying to get away from angularity and the kind of organization that had been familiar to me. Can one use angles like that? Why? Because joining one flush surface to another flush surface, 90 degrees against 90 degrees, or to make a 45-degree angle seems very acceptable, very much within a certain canon. To cut something at 38 degrees, for example, is unpredictable and results in capricious angles that are more expressive, reaching to the baroque.

86

Untitled, 1984,
Charcoal on paper,
43 x 30-3/4 in..

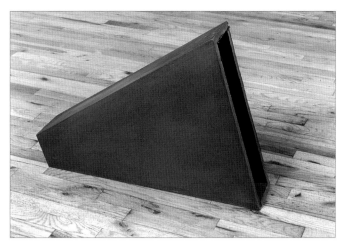

Untitled, 1984,
Cast iron, 21-1/2 x
29-1/2 x 5-3/4 in.

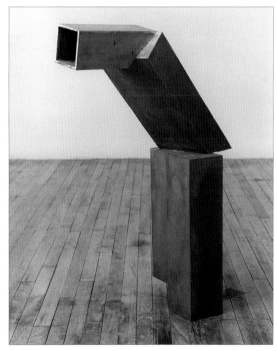

Untitled, 1985,
Bronze, Edition of 3,
38-1/2 x 28-1/2 x 14 in.

With the limbs, I was interested in attaining a compression in the center of the piece with extension around the sculpture, out into space. Compare it to a drawing from the period. I was struggling against prior drawings that were about the creation of form by folding and manipulating boundaries drawn in relation to the parameter of the page. In a way, this was a paradigm of Minimalism where the page determines the form rather than the drawing being a projection of thought, which interests me more.

I thought of this cast-iron piece as a torso. There is an entry on each side, and it is hollow, so you can see right through the piece. If you actually look at the piece as it tapers down, there is an illusion of it getting wider. This was another sculpture that I opened up: I left the top, or one side, off the piece, basically as a way of debunking bronze, and showing the hollow core or the work. I thought that this admission was effective, creating a pull into negative space.

Untitled, 1993-94, Plaster, 16-3/8 x 39-1/2 x 89-1/2 in.

I did this large coffin shape from 1993-94 when I was struggling against the figure. I had no place to go with the figure, and I was interested in casting, so I built these coffin shapes out of plywood and I cast plaster into the plywood. I was interested in the rigidity and smoothness of the outside and the suggestion of liquidity of the inside of the piece. So I poured plaster into these forms, building it up, until it became thick enough that it would support the form.

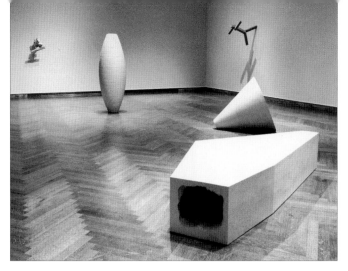

Installation view of exhibition *Joel Shapiro Sculpture in Clay, Plaster, Wood, Iron and Bronze, 1971-1997*, Addison Gallery of American Art, Andover, Massachusetts, September 20- January 4, 1998.

Another room, this one at the Addison Gallery, that was more contemplative, more internal. The Addison has quite beautiful rooms with a wood-pattern floor that is not unified, and it is a comfortable human space to look at work in, as compared to a museum like the Whitney, with its rough floor that is aggressive and dark and these sort of coffered ceilings that feel like they are going to fall on you.

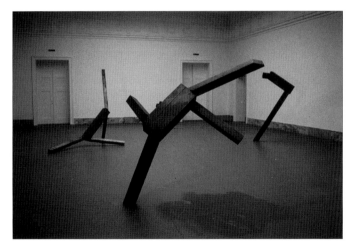

Installation view of exhibition *Joel Shapiro*, Staatliche Kunsthalle, Baden-Baden, Germany, February 1-March 31, 1986.

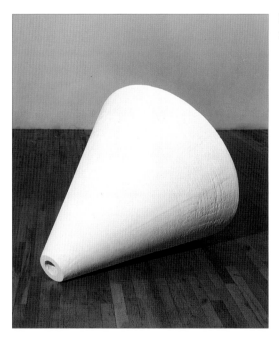

Untitled, 1984-85, Plaster, 36-1/2 x 42-1/2 x 39-1/4 in.

My installation strategies show my interest in how work functions in architectural space. Most galleries and museums are unaccommodating for work. The state museum in Baden-Baden is a very beautiful sort of turn-of-the-century space that's open, with a simple linoleum floor. I had four or five sculptures in the room and it was really breathtaking how they interacted with each other. The relationship between the pieces really results from the way each work was activated, compressed and expanding in different areas.

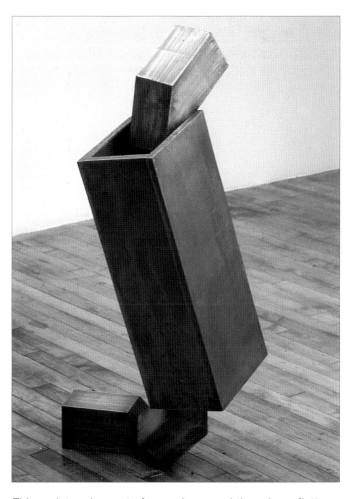

Untitled, 1986, Bronze,
Edition of 4,
37-1/2 x 15 x 15 in.

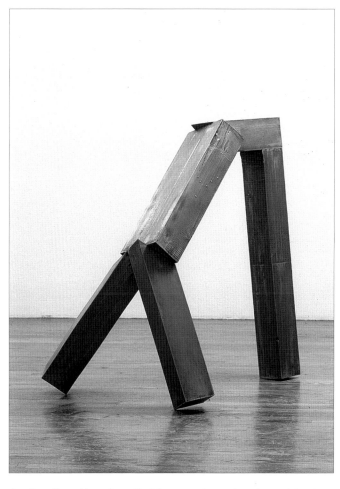

Untitled, 1987, Bronze,
Edition of 3,
48-3/8 x 51 x 34-1/4 in.

This sculpture is a sort of cone shape, and the volume flattens if you are looking at the front. It is like these three shapes going through a negative tube. I saw this piece as figurative, though I really don't know what generates the work. I am interested in finding a configuration that locates my thought at a given moment, so I would not say I am working towards something that I already know exactly. I am working towards what I don't know about and trying to find out what it is, what it is that I sense.

Another figurative piece that is very adamant and consistent is this one where I ripped the arms off and stuck them underneath the head, so it is sort of sitting there insistent. This piece was really about the elevation of mass, and trying to put this large chunk up off the ground at a precarious angle to accent its weight. My involvement with dislocation often necessitates attaining difficult configurations, but difficult configurations in my work are not about virtuosity. Supporting work from the ceiling, although a practical way of giving the sense of elevation from the ground that I want, would be too obvious.

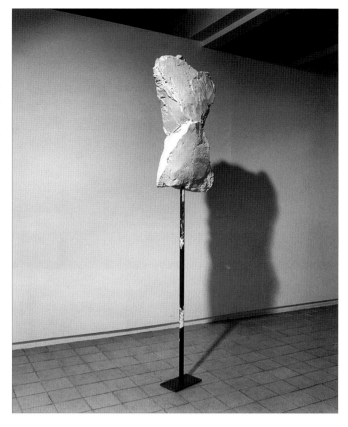

Untitled, 1987-88,
Plaster, Edition of 3,
72-1/2 x 15-1/2 x 10 in.
(stand: 43-1/2 in. high).

I am somebody who rarely models. This sculpture is one of
my few forays into modeling: I developed the form in plaster.
I've used modeling in contrast to the more geometric forms I
usually use. I think the contrast is interesting because the
development and gestation of modeling is so entirely different
than taking four pieces of wood and slapping them together.
Modeling is very useful, but it really does not suit my
temperament. I am interested in coming up with pieces,
thinking about work but not working, and then working, so
that it all happens very fast. I am less into a slow, ponderous
exploration of form. I find that drives me crazy. And also, I
don't know where I would go with modeling. It has been so
well developed by other artists, Matisse and Giacometti, and
maybe Picasso and Rodin. It seems it could be a dead end
now. Or it could be too internal; it doesn't have to be, of
course, if an individual comes along who has real depth and
can load up the work with meaning.

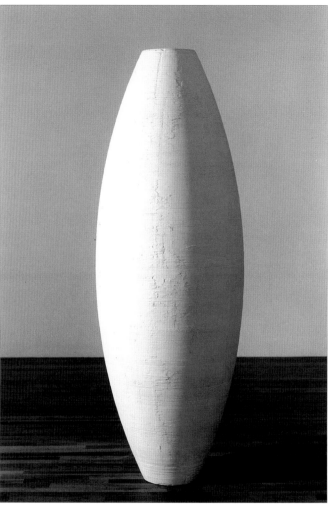

Untitled, 1987
(second version
1992), Plaster,
71 x 24-3/4 x
24-3/4 in.

Another plaster piece was kind of spun and it is life-size
and sort of encapsulates the figure. It is sort of phallic, sort
of a cocoon. When I showed this piece in Japan, it seemed
especially bomb-like. I just asked them, "What am I doing?"

90

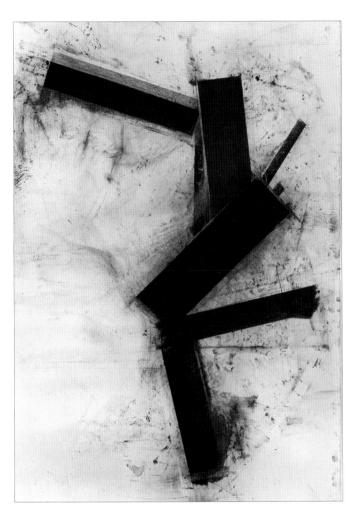

Untitled, 1988,
Charcoal and chalk on
paper, 88 x 60 in.

Untitled, 1989-90,
Bronze, Edition of 4,
102-1/2 x 43 x 78 in.

This drawing is one of the few instances in which I actually did a drawing that preceded a sculpture. I was again trying to make large pieces without the pieces becoming colossal, taking the strategy of stacking one on top of another to obtain height. This was an approach I had taken before, but I think that here there is also the effect of one form transcending another.

Untitled, 1989-90,
Bronze,
approx. 20 feet high.

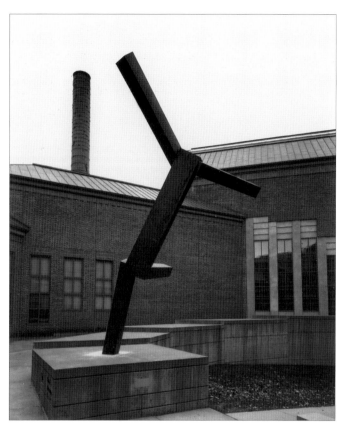

A piece for the Hood Museum of Art at Dartmouth College
was the largest piece I had done to date. It was attached to a
balustrade and I wanted the limbs to create a sense of falling
and falling back, and giving that sense by engaging the whole
space from the balustrade up to the wall.

Untitled, 1989-90,
Bronze, Edition of 4,
89 x 76-1/2 x 27 in..

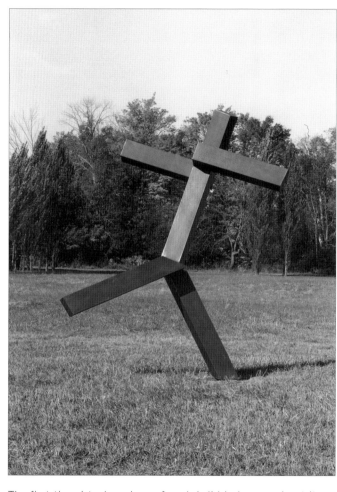

The first time I took a piece of work I did indoors and put it
outdoors, it had this profound effect. It reduced the space
around it, I thought, the way the chair had done. I'm not sure
if this effect has to do with the sort of geometry of the form
in relationship to the trees or the amount of ambient space
around the piece. I placed it slightly on the hill so it gained
some elevation.

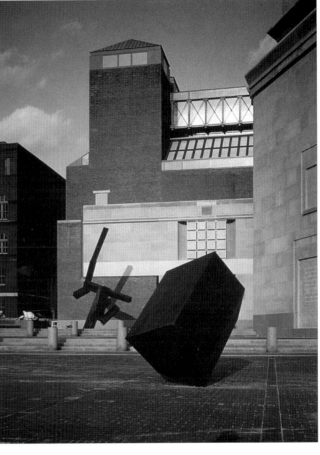

In 1989 I was asked if I was interested in competing for a sculptural commission at the United States Holocaust Memorial Museum in Washington, D.C. I felt that I could do something outside of the museum, and it could mediate between the outside and the inside. One proposal was a house attached to the building and a collapsing figure. The architect's response was, "Well, if you propose that, it will never happen. There is no way you could put that house on top of my building," which I thought was reasonable. In the final version, the house was tumbling down, inverted, as if it had fallen off the building, sprawled in front of the figure, which was more expressive, in a state of simultaneous collapse and expansion. It is 24 feet, but I still think it is not colossal. It doesn't even approach the grandiose because it is so fractured and the individual elements are comprehendible.

In the early '90s I began working with spheres again which I hadn't done since the early '70s. I was testing how the organization of sculpture was dependent on and determined by the rectilinear structure of architecture. How much of what one knows about a rectangle is in relation to other rectangles? So I began to deal with these nesting forms. They were about relationships, two together, one out. I think they kind of looked like cooties, but they were okay, they're fun.

Untitled, 1990, Bronze, 8-1/4 x 14 x 11-1/2 in.

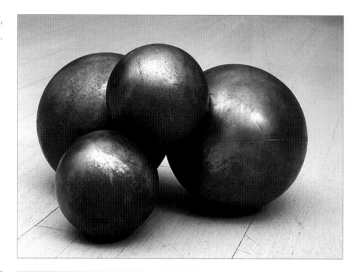

Installation view of exhibition, *Joel Shapiro: Sculpture and Drawings*, The Pace Gallery, 142 Greene Street, New York, April 30-June 25, 1993.

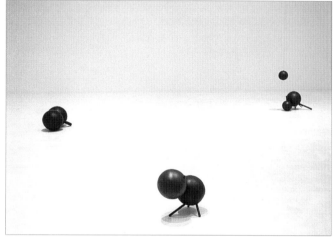

Untitled, 1993, Oil paint on wood, 59 x 74 x 36 in.

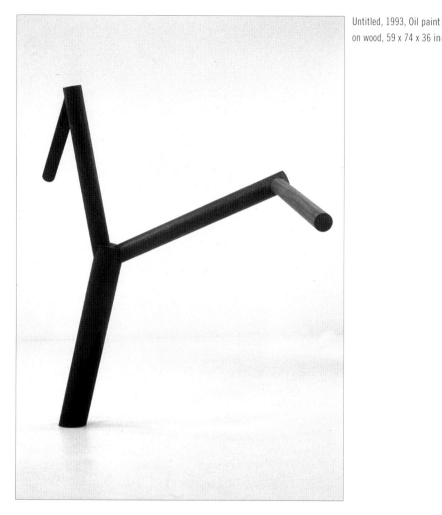

Trees and cylinders: these are painted wood, and I think are very touching. There was some issue of how far I could go with that. Maybe it will re-emerge in a future work. What interests me about these forms is that they basically do not refer to the geometry of the room or the geometry of the building. Does the work lose its scale because of that? It doesn't relate as much to the ground as my other work, which is often very much about its relationship to the ground and to the wall.

The thing that interests me about painting color is how it lets me avoid the major problem I encounter with wood, which is that it is too much about nature, and has a kind of misleading craft-ness. People really get involved in the craftsmanship, and I think they miss the form as a projection of thought. If you paint the form, then you project thought, and you develop meaning by pushing this other thought on the piece, reiterating thought and, of course, denying the wood.

94

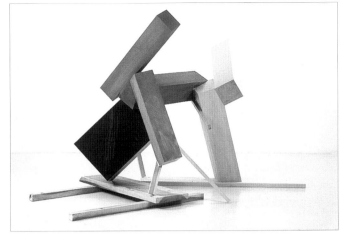

Untitled, 1993-94,
Oil paint on wood,
65 x 111 x 52 in.

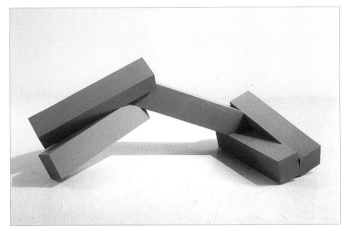

Untitled, 1997,
Oil paint on wood,
29 x 79 x 32-1/2 in.

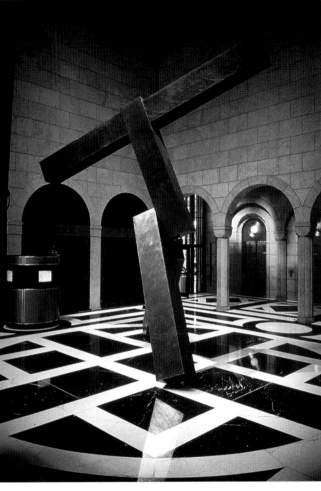

Untitled, 1994, Bronze,
21 feet high, Installed
at Sony Music
Entertainment
Corporation, New York.

A piece that is interesting in terms of how it functions in the space is this large sculpture in the lobby of the Sony Building in New York. The lobby is a monster. There's no question about it. It is. The space just doesn't work. Originally the piece was 18 feet, and it still had to be bigger, so I made it 22 feet. I was encouraged by the architect, who was great. I think the sculpture is big enough that when you go into that space you can't quite see it. One point of view can not encompass the piece, you have to walk around it. I think it really works, and maybe it is better in that location, because the piece really amplifies the space. There is, though, the danger of becoming a sculpture doctor, someone who goes in and fixes up problematic spaces.

People always ask me why I draw. What does it have to do with sculpture? I don't conceive of sculpture with drawing, but drawing allows me to probe ideas without having to deal with the mechanics of sculpture. These ideas might lead to a sculpture or they might not. I usually make wood models when working on sculpture. I might make six or seven models before I find a satisfactory form. Once I've found it, I'll make a larger model, and then eventually a pattern that will go to the foundry to be cast. All this is very physical and requires some amount of engineering. Drawing is a great relief because there is a page there, and of course you do have to think, but you don't have to deal with gravitational struggle.

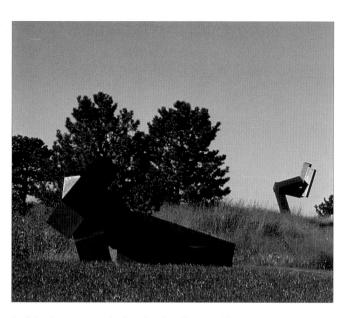

Three Figures/Fifteen Elements, 1994-96, Bronze, Three elements: 8 feet x 21 feet x 9 feet, 15 feet x 12 feet 6 in. x 7 feet 6 in., and 22 feet 6 in. x 18 feet x 10 feet 6 in., Installed at Kansas City International Airport, Kansas City, Missouri.

Three Figures/Fiftee. Elements, 1994-96, Bronze, Three elements: 8 feet x 21 feet x 9 feet, 15 feet x 12 fee 6 in. x 7 feet 6 in., and 22 feet 6 in. x 1 feet x 10 feet 6 in., Installed at Kansas City International Airport, Kansas City, Missouri.

I did a large commission for the Kansas City Airport. It was a nice project because the sculpture was to be located in a median. It was like drive-by sculpture. An artist whom I truly admire turned the commission down for exactly this reason. I was actually interested in that: what's wrong with seeing something at 45 miles an hour? They wanted one sculpture and I proposed three. You can only see them over a period of time. One of the three is 24 feet tall. This is getting colossal, but on the other hand, you don't get close to it. You just drive by it and that's when you see it. It is an effective strategy.

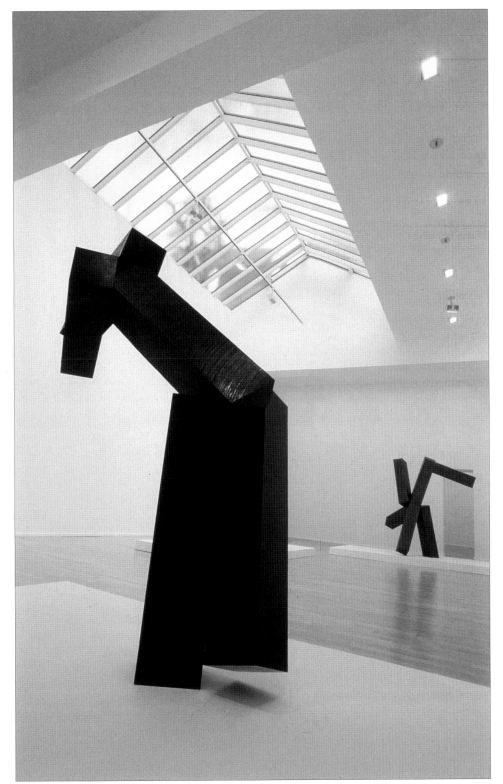

Installation view of exhibition *Joel Shapiro*, Galerie Jamileh Weber, Zürich, September 5-October 11, 1997.

I am deeply opposed to the base or the pedestal. It is not just me, most twentieth century artists gravitated away from the use of the pedestal. It isolates the sculpture from the ambient space. So I was doing this show last year in Zurich, in what I thought was a very beautiful space, designed by Dolf Schnebli, but they had a heating system in the floor which, for my work, was a nightmare. These pieces really have to be drilled into the floor and anchored, which could not happen in this space. So I had these bases made that were two meters by one meter—big plinths—and I put the work on the plinth. And actually the show was surprisingly warm and it had an accessibility that seemed kind of overwhelming. I still don't like the base. In this space, though, it did work. I think it was largely because there was no ceiling in the room, so that the room was not a kind of erected linear box.

97

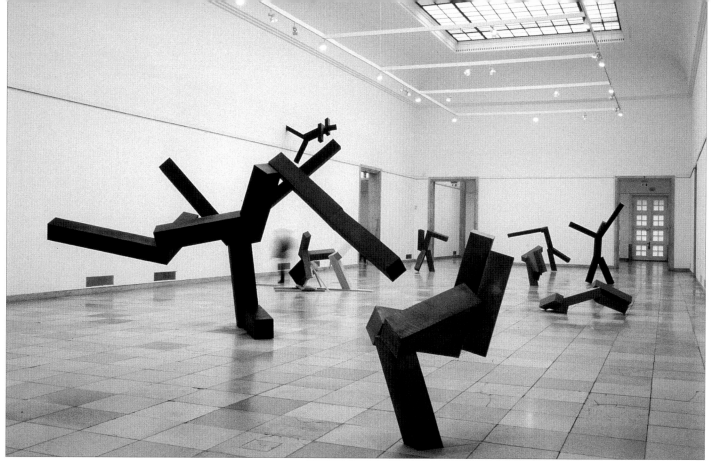

I just did a show in Munich at the Haus der Kunst. The space has a horrible history that is embedded in its form. It was built by Hitler in the 1930s to showcase Nazi art and was a site of much pageantry. It was so large that it seemed to me no sculpture—unless it was 30 feet tall—could really activate the space. I wanted to activate and engage the space. I decided to take a piece that already existed and change its context. I moved it from the floor and stuck it on the wall. On the wall, it has this way of breaking and fracturing the space as well as commenting on the history of the venue. It is bronze, and about seven feet. It was a big deal to put it up on the wall because nobody had plans of the building because, so they claimed, they were all destroyed during the G.I. Occupation in 1946. The wall is flimsy, but the floor was very strong since it was designed for large, heavy Nazi sculpture. I had a disturbing experience during the opening of the show while giving a little talk. The crowd of people was dwarfed by the colossal dimension of the room. I mean, no amount of humanity could activate this space. It is so oppressive, and the history of the venue so burdensome. And there was my oversize sculpture, peering over the crowd, insistent, adamant, and animate. I found that a little distressing. What am I doing in this space? I'm having a show, with this piece on the wall. It is installed about 18 feet high, and appears to be going up the wall. I'm sure no one will even touch this work, or what it was about in this particular space, or what the show could possibly mean.

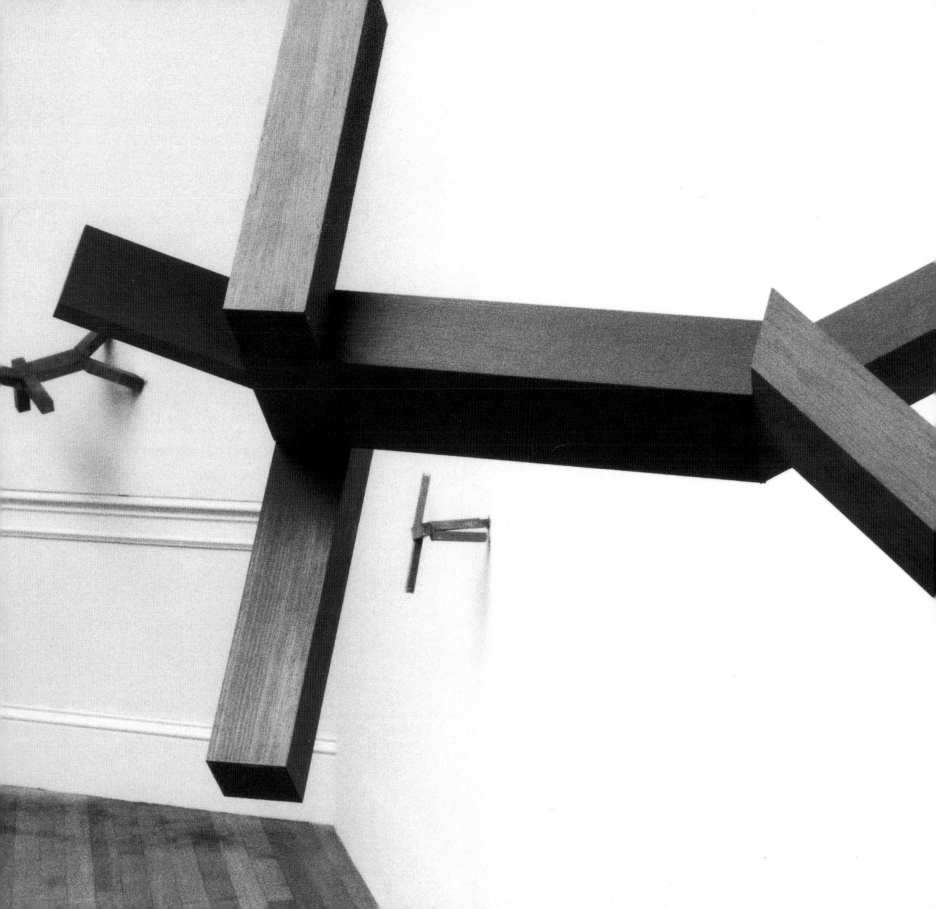

JOEL SHAPIRO

Born:	New York, New York, 1941
Education:	New York University, B.A., 1964
	Peace Corps, India, 1965-67
	New York University, M.A., 1969
Awards:	Visual Arts Fellowship, Visual Arts Program, National Endowment for the Arts, 1975
	Brandeis University Creative Arts Award, 1984
	Skowhegan Medal for Sculpture, 1986
	Award of Merit Medal for Sculpture, American Academy of Arts and Letters, New York, 1990
	Elected to the Swedish Royal Academy of Fine Arts, 1994
	Elected to the American Academy of Arts and Letters, 1998

SOLO EXHIBITIONS AND CATALOGUES

1970

Paula Cooper Gallery, New York. *Joel Shapiro*. March 8-April 1.

1972

Paula Cooper Gallery, New York. *Joel Shapiro*. January 15-February 9.

1973

The Clocktower, Institute for Art and Urban Resources, New York. *Joel Shapiro*. April 12-28.

1974

Paula Cooper Gallery, New York. *Joel Shapiro*. February 9-March 6.

Galleria Salvatore Ala, Milan. *Works by Joel Shapiro*. October 4-November 1.

1975

Walter Kelly Gallery, Chicago. *Joel Shapiro*. Dates not available.

Paula Cooper Gallery, New York. *Joel Shapiro*. October 11-November 5.

1976

Paula Cooper Gallery, Los Angeles. *Joel Shapiro*. April 6-24.

Museum of Contemporary Art, Chicago. *Joel Shapiro*. September 11-November 7. Exhibition catalogue, text by Rosalind Krauss.

1977

Max Protetch Gallery, Washington, D.C. *Joel Shapiro. Recent Sculpture*. February 19-March 20.

Albright-Knox Art Gallery, Buffalo. *Joel Shapiro. Recent Work*. March 26-April 17. Exhibition catalogue, text by Linda Cathcart.

Susanne Hilberry Gallery, Birmingham, Michigan. *Recent Sculpture: Joel Shapiro*. April 16-May 14.

Paula Cooper Gallery, New York. *Joel Shapiro*. November 12-December 7.

Galerie Aronowitsch, Stockholm. *Joel Shapiro*. November 19-December 15.

Galerie Nancy Gillespie-Elisabeth de Laage, Paris. *Joel Shapiro: Drawings*. November 19-December 15.

1978

The Greenberg Gallery, St. Louis. *Joel Shapiro. New Sculptures*. March 16-April 30.

Galerie m, Bochum, West Germany. *Joel Shapiro*. Dates not available.

1979

Akron Art Institute. *Joel Shapiro. Sculpture*. February 3-March 18.

Galerie Mukai, Tokyo. *Joel Shapiro: Sculpture & Dessin*. April 11-May 10.

Paula Cooper Gallery, New York. *Joel Shapiro*. April 14-May 12.

Galerie Nancy Gillespie-Elisabeth de Laage, Paris. *Joel Shapiro*. May 19-June 21.

The University Gallery, Ohio State University, Columbus. Spring.

1980

Whitechapel Art Gallery, London. *Joel Shapiro: Sculpture and Drawing*. January 18-February 24. Traveled to Museum Haus Lange, Krefeld, West Germany, March 16-April 27; Moderna Museet, Stockholm, October 31-December 14. Exhibition catalogue, text by Roberta Smith.

Galerie Mukai, Tokyo. *Joel Shapiro*. April 11-May 10.

Asher/Faure Gallery, Los Angeles. *Joel Shapiro*. June 7-July 3.

Brooke Alexander, Inc., New York. *Joel Shapiro: Lithographs, 1979-1980.* September 9-October 4. Traveled to Delahunty Gallery, Dallas, October 11-November 5. Exhibition catalogue.

Galerie Aronowitsch, Stockholm. *Joel Shapiro*. November 8-November 25.

Paula Cooper Gallery, New York. *Joel Shapiro*. November 19-December 13.

David Winton Bell Gallery, List Art Center, Brown University, Providence, Rhode Island. *Joel Shapiro*. November 22-December 17. Traveled to Georgia State University, Atlanta, February 2-27, 1981; The Contemporary Arts Center, Cincinnati, September 17-November 1, 1981. Exhibition catalogue, text by William Jordy.

1981

William Hayes Ackland Art Museum, University of North Carolina at Chapel Hill. *Facets I: Joel Shapiro*. January 11-February 8.

John Stoller Gallery, Minneapolis. *Joel Shapiro: Sculpture, Drawings, Prints*. April 10-June 28.

Daniel Weinberg Gallery, San Francisco. *Joel Shapiro: Recent Sculpture*. May 5-June 6.

The Israel Museum, Jerusalem. *Joel Shapiro*. September-October. Exhibition catalogue, text by Stephanie Rachum.

Galerie Mukai, Tokyo. *Joel Shapiro: Sculpture*. October 5-October 24.

Young Hoffman Gallery, Chicago. *Joel Shapiro: Sculptures and Drawings, 1975 through 1981*. November 20-January 5, 1982.

1982

Paula Cooper Gallery, New York. *Joel Shapiro: Drawings*. January 9-February 6.

Portland Center for the Visual Arts, Oregon. *Joel Shapiro*. March 30-May 2.

Susanne Hilberry Gallery, Birmingham, Michigan. *Joel Shapiro: New Sculptures and Drawings*. April 3-June 4.

Yarlow/Salzman Gallery, Toronto. *Joel Shapiro: Recent Sculptures and Drawings*. April 6-May 1.

Whitney Museum of American Art, New York. *Joel Shapiro*. October 21-January 2, 1983. Traveled to Dallas Museum of Arts, March 9-May 8, 1983; Art Gallery of Ontario, Toronto, August 13-May 8, 1983; La Jolla Museum of Contemporary Art, December 3-January 15, 1984. Exhibition catalogue, texts by Richard Marshall and Roberta Smith.

1983

Paula Cooper Gallery, New York. *Joel Shapiro*. May 5-June 4.

Asher/Faure Gallery, Los Angeles. *Joel Shapiro*. November 19-December 24.

1984

Paula Cooper Gallery, New York. *Joel Shapiro: Gouaches*. March 22-April 14.

Galerie Aronowitsch, Stockholm. *Joel Shapiro*. Opened May 5.

Paula Cooper Gallery, New York. *Joel Shapiro*. November 1-29.

1985

Knoedler Kasmin, London. *Joel Shapiro*. June 20-July.

Stedelijk Museum, Amsterdam. *Joel Shapiro*. September 6-October 20. Traveled to Kunstmuseum Düsseldorf, Germany, November 10-January 19, 1986; Staatliche Kunsthalle, Baden-Baden, Germany, February 1-March 31, 1986. Exhibition catalogue, texts by Marja Bloem and Karel Schampers.

1986

Seattle Art Museum. *Joel Shapiro*. March 13-May 11.

Galerie Daniel Templon, Paris. *Joel Shapiro*. March 9-May 3.

John and Mable Ringling Museum of Art, Sarasota, Florida. *Joel Shapiro*. October 31-December 14. Exhibition catalogue, text by Mark Ormond.

Paula Cooper Gallery, New York. *Joel Shapiro*. November 8-December 6.

Asher/Faure Gallery, Los Angeles. *Joel Shapiro*. November 15-December 20.

Hal Bromm Gallery, New York. *Joel Shapiro*. September 12-October 11.

1987

Donald Young Gallery, Chicago. *Joel Shapiro*. April 3-May 2, 1987.

John Berggruen Gallery, San Francisco. *Joel Shapiro*. September 30-November 28.

Hirshhorn Museum and Sculpture Garden, Smithsonian Institution, Washington, D.C. *Joel Shapiro: Painted Wood*. December 2-February 28, 1988. Exhibition brochure, text by Ned Rifkin.

1988

Paula Cooper Gallery, New York. *Joel Shapiro*. March 3-March 31.

Gallery Mukai, Tokyo. *Joel Shapiro*. April 4-May 7. Exhibition catalogue, text by Lynne Cooke.

Hans Strelow, Düsseldorf. *Joel Shapiro*. April 29-June 4.

Susanne Hilberry Gallery, Birmingham, Michigan. *Joel Shapiro*. May 21-June 22.

Galerie Daniel Templon, Paris. *Joel Shapiro*. September 10-October 12.

The Cleveland Museum of Art. *Joel Shapiro: Recent Sculptures and Drawings*. Dates not available.

1989

Asher/Faure Gallery, Los Angeles. *Joel Shapiro*. January 14-February 11.

The Toledo Museum of Art. *Playing with Human Geometry: Joel Shapiro's Sculpture*. January 15-February 26.

Paula Cooper Gallery, New York. *Joel Shapiro*. May 3-June 3.

Waddington Galleries, London. *Joel Shapiro*. October 4-October 28. Exhibition catalogue, text by Lynne Cooke.

1990

Pace Prints, New York. *Joel Shapiro*. May 4-June 3.

The Greenberg Gallery, St. Louis. *Joel Shapiro*. May 24-July 21.

Museet i Varberg, Sweden. *Joel Shapiro Skulptur & Grafik 1985-1990*. June 17-August 19. Exhibition catalogue, text by Staffan Schmidt.

Galerie Aronowitsch, Stockholm. *Joel Shapiro*. September 1-29.

Paula Cooper Gallery, New York. *Joel Shapiro*. November 3-December 1.

Des Moines Art Center. *Joel Shapiro: Tracing the Figure*. November 17, 1990-January 13, 1991. Traveled previously to Baltimore Museum of Art, August 21-October 7, 1990; Center for the Fine Arts, Miami, April 6-June 2, 1991. Exhibition catalogue, texts by Donald Kuspit and Deborah Leveton.

Louisiana Museum for Moderne Kunst, Humlebaek, Denmark. *Joel Shapiro*. September 15-November 18. Traveled to IVAM Centre Julio González, Valencia, November 29-February 10, 1991; Kunsthalle Zürich, March 23-May 26, 1991; Musée des Beaux-Arts, Calais, June 22-September 8, 1991. Exhibition catalogue, texts by Nancy Princenthal and Rosalind Krauss.

1991

Salon de Mars, Paris. *Joel Shapiro*. March 20-25.

Center for the Fine Arts, Miami. *Joel Shapiro: Selected Drawings 1968-1990*. April 6-June 2. Exhibition catalogue, texts by Mark Ormond and Paul Cummings.

Asher/Faure Gallery, Los Angeles. *Joel Shapiro*. April 20-May 18.

Gallery Mukai, Tokyo. *Joel Shapiro*. May 10-June 8. Exhibition catalogue.

John Berggruen Gallery, San Francisco. *Recent Sculpture*. October 30-November 30.

1993

The Pace Gallery, 32 East 57th Street, and 142 Greene Street, New York. *Joel Shapiro: Sculpture and Drawings*. April 30-June 18 (East 57th St.) and April 30-June 25 (Greene St.). Exhibition catalogue, text by Peter Schjeldahl.

Galerie Karsten Greve, Cologne. *Joel Shapiro: Skulpturen/Arbeiten auf Papier*. September 23-January 6, 1994.

1994

Gallery Seomi, Seoul. *Joel Shapiro: Drawing & Sculpture*. April 19-May 18. Exhibition brochure, text by Choi Insu.

Galleria Karsten Greve, Milan. *Joel Shapiro: Sculture e Disegni*. September 8-November 8.

1995

Galerie Aronowitsch, Stockholm. *Joel Shapiro: Teckningar*. February 11-March 15.

PaceWildenstein, 32 East 57th Street, New York. *Joel Shapiro: Painted Wood Sculpture and Drawings*. March 24-April 22. Exhibition catalogue, interview with Joel Shapiro by Ellen Phelan.

Galerie Karsten Greve, Paris. *Joel Shapiro Sculptures*. May 4-August 31.

Betsy Senior Gallery, New York. *Joel Shapiro: Etchings*. October 26-December 22.

Walker Arts Center/Minneapolis Sculpture Garden. *Joel Shapiro: Outdoors*. May 15-March 15, 1996. Traveled to The Nelson-Atkins Museum of Art/Kansas City Sculpture Park, April 23-March 31, 1997. Exhibition catalogue, texts by Deborah Emont Scott and Peter Boswell.

1996

Susanne Hilberry Gallery, Birmingham, Michigan. *Joel Shapiro: New Etchings and Painted Wood Sculptures*. February 6-March 30.

Daniel Weinberg Gallery, San Francisco. *Joel Shapiro: Early Works*. March 9-April 27.

PaceWildenstein, Los Angeles. *Joel Shapiro: Sculpture & Drawings*. March 14-April 20. Exhibition catalogue, text by Michael Brenson.

University of Missouri-Kansas City Gallery of Art. *Joel Shapiro: Selected Prints 1975-1995*. September 7-October 25.

PaceWildenstein, 142 Greene Street, New York. *Joel Shapiro: Recent Sculpture*. September 26-November 2.

Gallery Seomi, Seoul. *Joel Shapiro: Recent Sculpture and Drawings*. November 12-December 20. Exhibition catalogue, text by Sung Hee Kim.

1997

Galerie Jamileh Weber, Zürich. *Joel Shapiro*. September 5-October 11.

Addison Gallery of American Art, Phillips Academy, Andover, Massachusetts. *Joel Shapiro: Sculpture in Clay, Plaster, Wood, Iron, and Bronze, 1971-1997*. September 20-January 4, 1998.

Galerie Biedermann, Munich. *Joel Shapiro: Drawings*. October 24-December 3.

Haus der Kunst, Munich. *Joel Shapiro: Skulpturen 1993-1997*. October 24-January 6,1998. Traveled to Barlack Halle K, Hamburg, February 6-March 22, 1998.

SELECTED GROUP EXHIBITIONS AND CATALOGUES

1969

Whitney Museum of American Art, New York. *Anti-Illusion: Procedure/Material*. May 19-July 6. Exhibition catalogue, texts by Marcia Tucker and James Monte.

1970

The Emily Lowe Gallery, Hofstra University, Hempstead, New York. *Hanging/Leaning*. February 2-27. Exhibition catalogue, Introduction by Robert R. Littman.

The Museum of Modern Art, New York. *Paperworks*. November 24-January 10, 1971.

Whitney Museum of American Art, New York. *1970 Annual Exhibition: Contemporary American Sculpture*. December 12-February 7, 1971. Exhibition catalogue, Foreword by John I. H. Baur.

1971

Vassar College Art Gallery, Poughkeepsie, New York. *Twenty-six by Twenty-six*. May 1-June 6. Exhibition catalogue, texts by Mary Delahoyd, Marguerite Klobe, Robin Brown, Nancy Cara Ackerman, and Stephen Martin.

1972

The Aldrich Museum of Contemporary Art, Ridgefield, Connecticut. *Paintings on Paper*. September 17-December 17.

1973

Whitney Museum of American Art, New York. *American Drawings 1963-1973*. May 25-July 22. Exhibition catalogue, text by Elke M. Solomon.

Fogg Art Museum, Harvard University, Cambridge, Massachusetts. *New American Graphic Art*. September 12-October 28.

1974

Indianapolis Museum of Art. *Painting and Sculpture Today, 1974*. May 22-July 14. Traveled to The Taft Museum, Cincinnati, September12-October 26. Exhibition catalogue.

The Art Institute of Chicago. *Seventy-first American Exhibition* June 15-August 11. Exhibition catalogue, Introduction by A. James Speyer.

1975

The Garage, London. *Jennifer Bartlett and Joel Shapiro*. April 23-May 17.

The Art Institute of Chicago. *The Small Scale in Contemporary Art*. May 8-June 15. Exhibition catalogue, text by Peter Frank.

The Clocktower, Institute for Art and Urban Resources, New York. *Collectors of the Seventies, Part III: Milton Brutton and Helen Herrick*. September18-October 18.

Institute of Contemporary Art, University of Pennsylvania, Philadelphia. *Painting, Drawing, and Sculpture of the '60s and '70s from the Dorothy and Herbert Vogel Collection*. October 7-November 18. Traveled to The Contemporary Arts Center, Cincinnati, December 17-February 15, 1976.

1976

Fine Arts Center Gallery, University of Massachusetts, Amherst. *Critical Perspectives in American Art*. April 10-May 9. Traveled to United States Pavilion, 37th Venice Biennale, July 18-October 10. Exhibition catalogue, Introduction by Hugh M. Davies, texts by Sam Hunter, Rosalind Krauss and Marcia Tucker.

Art Gallery of New South Wales, Sydney. *Biennale of Sydney: Recent International Forms in Art*. November 13-December 19. Exhibition catalogue.

1977

Whitney Museum of American Art, New York. *1977 Biennial Exhibition: Contemporary American Art*. February 15-April 3. Exhibition catalogue, Foreward by Tom Armstrong, Introduction by Barbara Haskell, Marcia Tucker, and Patterson Sims.

Institute of Contemporary Art, University of Pennsylvania, Philadelphia. *Improbable Furniture*. March 10-April 10. Traveled to La Jolla Museum of Contemporary Art, California, May 20-July 6. Exhibition catalogue, texts by Suzanne Delahunty and Robert Pincus-Witten.

The Renaissance Society at the University of Chicago. *Ideas in Sculpture 1965-1977*. May 1-June 11. Exhibition catalogue, text by Anne Rorimer.

Kassel, Germany. *Documenta 6*. June 24-October 2. Exhibition catalogue.

Museum of Contemporary Art, Chicago. *Ten Years: A View of a Decade*. September 10-November 10. Exhibition catalogue, Introduction by Stephen Prokopoff, texts by Martin Friedman, Robert Pincus-Witten and Peter Gay.

Walker Art Center, Minneapolis. *Scale and Environment: 10 Sculptors*. October 2-November 27. Exhibition catalogue, Introduction by Martin Friedman, texts by Michael R. Klein, Laurence Shopmaker, Lisa Lyons and Judith Hoos Fox.

The New Museum of Contemporary Art, New York. *Early Work by Five Contemporary Artists: Ron Gorchov, Elizabeth Murray, Dennis Oppenheim, Dorothea Rockburne, Joel Shapiro*. November 11-December 30. Exhibition catalogue, Introduction by Marcia Tucker, interviews by Susan Logan, Allan Schwartzman and Marcia Tucker.

1978

P.S. 1, Institute for Art and Urban Resources, Long Island City, New York. *Indoor/Outdoor*. May 16-May 21.

Stedelijk Museum, Amsterdam. *Made by Sculptors*. September 14-November 5. Exhibition catalogue, texts by Rini Dippel and Geert van Beijeren.

Institute of Contemporary Art, University of Pennsylvania, Philadelphia. *Dwellings*. October 20-November 25. Traveled to Neuberger Museum, State University of New York at Purchase, New York. Exhibition catalogue, Acknowledgments by Suzanne Delahunty, text by Lucy R. Lippard.

1979

William Hayes Ackland Art Museum, University of North Carolina at Chapel Hill. *Drawings About Drawing: New Directions in the Medium (1968-1978)*. January 28-March 11. Exhibition catalogue, text by Innis W. Shoemaker.

Whitney Museum of American Art, New York. *1979 Biennial Exhibition*. February 6-April 8. Exhibition catalogue, Preface by Tom Armstrong, Foreward by John G. Hanhardt, Barbara Haskell, Richard Marshall, Mark Segal and Patterson Sims.

University Art Museum, University of California, Santa Barbara. *Sculptural Perspectives: An Exhibition of Small Sculpture of the 70s*. February 14-March 25. Exhibition catalogue, text by Phyllis Plous.

The Aldrich Museum of Contemporary Art, Ridgefield, Connecticut. *The Minimal Tradition*. April 29-September 2. Exhibition catalogue, Preface by Richard E. Anderson, Introduction by Dorothy Mayhall.

1980

Kulturhistorisches Museum, Bielefeld, West Germany. *Zeitgenössische Plastik*. April 20-June 15. Exhibition catalogue, texts by Erick Franz, Annelie Pohlen, Ann Lauterbach and Alain Kirili.

The Institute of Contemporary Art, Boston. *Drawings/Structures*. May 7-June 29. Exhibition catalogue, text by Stephen Prokopoff.

Hayward Gallery, London. *Pier + Ocean: Construction in the Art of the Seventies*. May 8-June 22. Traveled to the Rijksmuseum Kröller-Müller, Otterlo, July 13-September 8. Exhibition catalogue, Introduction by Gerhard von Gravenitz.

Westfälisches Landesmuseum für Kunst und Kulturgeschichte, Münster. *Reliefs, Formprobleme zwischen Malerei und Skulptur im 20. Jahrhundert*. June 1-August 3. Traveled to Kunsthaus Zürich, August 28-November 2. Exhibition catalogue.

United States Pavilion, 39th Venice Biennale. *Drawings: The Pluralist Decade*. June 1-September 30. Traveled to the Institute of Contemporary Art, University of Pennsylvania, Philadelphia, October 4-November 9; Museum of Contemporary Art, Chicago, May 29-June 26, 1981. Exhibition catalogue, Introduction by Janet Kardon, texts by John Hallmark Neff, Rosalind Krauss, Richard Lorber, Edit deAk, John Perrault, Howard N. Fox, and Nancy Foote.

Los Angeles Institute of Contemporary Art. *Architectural Sculpture*. September 30-November 21. Exhibition catalogue, Foreward by Robert L. Smith, Introduction by Debra Burchett, texts by Susan C. Larsen, Lucy R. Lippard, and Melinda Wortz.

1981

Whitney Museum of American Art, New York. *1981 Biennial Exhibition*. February 4-April 19. Exhibition catalogue, Foreword by Tom Armstrong, Preface by John G. Hanhardt, Barbara Haskell, Richard Marshall, and Patterson Sims.

Visual Arts Museum, School of Visual Arts, New York. *Sculptural Density*. March 30-April 24.

Louisiana Museum of Modern Art, Humlebaek, Denmark. *Amerikanische Zeichnungen der Siebziger Jahre*. August 15-September 20. Traveled to Kunsthalle Basel, October 4-November 18; Städtische Galerie im Lenbachhaus, Munich, February 16-April 11; Wilhelm-Hack-Museum, Ludwigschafen,September-October 1982. Exhibition catalogue, texts by Richard Armstrong, Alfred Kren, Carter Ratcliff, and Peter Schjeldahl.

Akron Art Museum. *The Image in American Painting and Sculpture, 1950-1980*. September 12-November 8. Exhibition catalogue, Foreward by Tom Armstrong, text by Paul Cummings.

Rice University Art Gallery, Sewall Hall, Houston. *Variants: Drawings by Contemporary Sculptors*. November 2-December 12. Traveled to Art Museum of South Texas, Corpus Christi, December 31, 1981-January 28, 1982; The High Museum of Art, Atlanta, March 26-May 2, 1982. Exhibition catalogue, text by Esther de Vécsey.

Hayden Gallery, Massachusetts Institute of Technology, Cambridge. *Body Language: Figurative Aspects of Recent Art*. November 21-December 24. Exhibition catalogue.

Albright-Knox Art Gallery, CEPA Gallery, and Hallwalls, Buffalo. *Figures: Forms and Expressions*. November 21-January 3, 1982. Exhibition catalogue, texts by Carlotta Kotik, Susan Krane, Robert Cottington, Biff Henrich, William Currie, and G. Roger Denson.

1982

Kassel, Germany. *Documenta 7*. June 19-September 29.

San Francisco Museum of Modern Art. *Twenty American Artists: Sculpture 1982*. July 22-September 19. Exhibition catalogue, Foreword by Henry T. Hopkins, Introduction by George W. Neubert.

The Aldrich Museum of Contemporary Art, Ridgefield, Connecticut. *PostMINIMALism*. September 19-December 19. Exhibition catalogue.

Palacio de las Alhajas, Madrid. *Correspondencias: 5 Arquitectos, 5 Escultores*. October-November 1982. Traveled to Malaga and Bilbao, Spain. Exhibition catalogue, texts by Carmen Gimenez and Juan Munoz.

1983

School of Visual Arts, New York. *BIG American Figure Drawings*. March 7-March 24.

Moderna Museet, Stockholm. *Moderna Museet 1958-1983*. 25th Anniversary: May 9, 1983. Exhibition catalogue.

Whitney Museum of American Art, New York. *Minimalism to Expressionism: Painting and Sculpture Since 1965 from the Permanent Collection*. June 2-December 14.

The Tate Gallery, London. *New Art*. September 14-October 23. Exhibition catalogue, text by Michael Compton.

The New Museum of Contemporary Art, New York. *Language, Drama, Source and Vision*. September 23-November 9.

The Museum of Contemporary Art, Los Angeles. *The First Show: Painting and Sculpture from Eight Collections 1940-1980*. Opened November 18. Exhibition catalogue.

1984

Whitney Museum of American Art, New York. *American Art Since 1970: Painting, Sculpture, and Drawings from the Collection of the Whitney Museum of American Art, New York.* Traveled to La Jolla Museum of Contemporary Art, California, March 10-April 22; North Carolina Museum of Art, Raleigh, September 29-November 25; Sheldon Memorial Art Gallery and Sculpture Gardens, University of Nebraska, Lincoln. January 12-March 3, 1985; Center for the Fine Arts, Miami, March 30-June 2, 1985; Exhibition catalogue, text by Richard Marshall.

Hirshhorn Museum and Sculpture Garden, Smithsonian Institution, Washington, D.C. *Drawings 1974-1984.* March 15-May 13. Exhibition catalogue, text by Frank Gettings.

The Museum of Modern Art, New York. *An International Survey of Recent Painting and Sculpture.* May 17-August 19. Exhibition catalogue.

Williams College Museum of Art, Williamstown, Massachusetts and the Museum of Fine Arts, Boston. *The Modern Art of the Print: Selections from the Collection of Lois and Michael Torf.* Williams College Museum of Art, May 5-July 16, and Museum of Fine Arts, Boston, August 1-October 14. Exhibition catalogue, texts by Clifford S. Ackley, Thomas Krens and Deborah Menaker.

The Parrish Art Museum, Southampton, New York. *Forming.* July 29-September 23. Exhibition catalogue, text by Klaus Kertess.

The Bruce Museum, Greenwich, Connecticut. *Sculpture: The Language of Scale.* September 15-December 1. Exhibition catalogue.

The Newark Museum, New Jersey. *American Bronze Sculpture: 1850 to the Present.* October 18-February 3, 1985. Exhibition catalogue, text by Gary A. Reynolds.

The Seattle Art Museum. *American Sculpture: Three Decades.* November 15-January 27, 1985.

1985

Frankfurter Kunstverein, Frankfurt, Germany. *Vom Zeichen-Aspekte der Zeichnung 1960-1986.* Traveled to Kasseler Kunstverein, Kassel, Germany; Museum Moderner Kunst, Vienna. Exhibition catalogue.

The Contemporary Arts Center, Cincinnati. *Body and Soul: Aspects of Recent Figurative Sculpture.* September 6-October 12, 1985. Exhibition catalogue, text by Sarah Rogers-Lafferty.

Sheldon Memorial Art Gallery and Sculpture Gardens, University of Nebraska, Lincoln. *Contemporary Bronze: Six in the Figurative Tradition.* November 19-January 19, 1986. Traveled to Kansas City Art Institute, Kansas City, Missouri, February 13-March 20, 1986; Des Moines Art Center, Iowa, April 8-June 1, 1986. Exhibition catalogue, Introduction by George W. Neubert, artist biographies by Vivian Kiechel.

Solomon R. Guggenheim Museum, New York. *Transformations in Sculpture.* November 22-February 16, 1986. Exhibition catalogue, text by Diane Waldman.

1986

Museum of Art, Inc., Fort Lauderdale, Florida. *American Renaissance: Painting and Sculpture Since 1940.* January 12-March 30. Exhibition catalogue, Edited with an Introduction by Sam Hunter, texts by Malcolm R. Daniel, Harry F. Gaugh, Sam Hunter, Karen Koehler, Kim Levin, Robert C. Morgan, and Richard Sarnoff.

The Corcoran Gallery of Art, Washington D.C. *Spectrum: The Generic Figure.* March 8-April 20. Exhibition catalogue.

Palacio de Velazquez, Madrid. *Between Geometry and Gesture: American Sculpture 1965-1975.* May 13-July 20. Exhibition catalogue, Introduction by Richard Armstrong and Richard Marshall, texts by Carmen Gimenez, Richard Armstrong, Marga Paz, text on Joel Shapiro by James Collins.

The Museum of Contemporary Art, Los Angeles. *The Barry Lowen Collection.* June 16-August 10. Exhibition catalogue, text by Christopher Knight.

Frankfurter Kunstverein, Frankfurt, Germany. *Prospect 86.* September 9-November 2. Exhibition catalogue, Introduction by Peter Weiermair, text on Joel Shapiro by Manfred Schneckenburger.

Phoenix Art Museum. *Focus On The Image: Selections from the Rivendell Collection.* October 5-February 7, 1987. Traveled to The Fred Jones Jr. Museum of Art, Norman, Oklahoma, April 25-August 30, 1987; Munson-Williams-Proctor Institute Museum of Art, Utica, New York, September 27, 1987-March 20, 1988; University of South Florida Art Galleries, Tampa, Florida, April 17-September 10, 1988; Lakeview Museum of Art and Sciences, Lakeview, Illinois, October 1, 1988-January 2, 1989; University Art Museum, California State University, Long Beach, California, January 30-May 28, 1989; Laguna Gloria Art Museum, Austin, Texas, June 25, 1989-January 2, 1990. Exhibition catalogue, texts by Nina Felshin and Thomas McEvilley.

The Museum of Contemporary Art, Los Angeles. *Individuals: A Selected History of Contemporary Art 1945-1986*. December 6-January 10, 1987. Exhibition catalogue.

1987

Wadsworth Atheneum, Hartford, Connecticut. *From the Collection of Sol LeWitt*. March 12-May 24.

Dallas Museum of Art. *A Century of Modern Sculpture: The Patsy and Raymond Nasher Collection*. April 5-May 31. Traveled to The National Gallery of Art, Washington, D.C., June 28-January 3, 1988. Exhibition catalogue, texts by Elizabeth Frank, Steven A. Nash, Nan Rosenthal, and Robert Rosenblum.

Ushimado, Japan. *The Fourth Japan Ushimado International Art Festival*. November 1-3. Exhibition catalogue.

Lannan Museum, Lake Worth, Florida. *Abstract Expressions: Recent Sculpture*. December 18-May 10, 1988. Exhibition catalogue, text by Bonnie Clearwater.

1988

Williams College Museum of Art, Williamstown, Massachusetts. *Big Little Sculpture*. February 13-April 17. Traveled to Plymouth State College Art Gallery, Plymouth, New Hampshire, October 12-November 5; New Britain Museum of American Art, New Britain, Connecticut, November 13-January 5, 1989; Middlebury College, Johnson Art Gallery, Middlebury, Vermont, January 15-February 26, 1989; St. Paul's School, Art Center in Hargate, Concord, New Hampshire, April 4-May 20, 1989. Exhibition catalogue, text by Phyllis Tuchman.

The Saatchi Collection, London. *Philip Guston, Joel Shapiro, Leon Golub, Sigmar Polke*. April 29-September. Exhibition catalogue, text by Peter Schjeldahl.

The Aldrich Museum, Ridgefield, Connecticut. *Innovations in Sculpture*. September 24-December 31.

The Carnegie Museum of Art, Pittsburgh. *Carnegie International*. November 5-January 22, 1989. Exhibition catalogue, essays by Thomas McEvilley, Lynne Cooke, Milena Kalinovska, text on Joel Shapiro by Kellie Jones.

Instituto de Estudios Norteamericanos, Barcelona. *Sightings: Drawing with Color*. November 16-December 16. Traveled to Casa Revilla, Valladolod, Spain, December 27-January 20, 1989; Museo Barjola, Gijón, Spain, February 1-28, 1989; Calouste Gulbenkian Foundation, Lisbon, March 6-April 7, 1989; Pratt Manhattan Gallery, New York, April 24-May 20, 1989; Rubelle & Norman Schafler Gallery, Pratt Institute, Brooklyn, June 12-July 7, 1989. Exhibition catalogue, text by Donald Kuspit.

Museum of Contemporary Art, Chicago. *Three Decades: The Oliver-Hoffman Collection*. December 17-February 5, 1989. Exhibition catalogue, texts by Camille Oliver-Hoffman, I. Michael Danoff, Phyllis Tuchman, Lynne Warren, and Bruce Guenther.

1989

Institut Néerlandis, Paris. *Amsterdam/Art: Regards: dessins contemporains*. January 19-March 5. Exhibition catalogue, text by Ad Petersen.

The Arkansas Arts Center, Little Rock. *Revelations Drawing/America*. January 19-March 26. Traveled to Umjetnicka Galerija Bosne I Hercegovine, Sarajevo, Yugoslavia, June 7-28, 1988; Moderna Galerija, Ljubljana, Yugoslavia, July 5-August 5, 1988; Galerija Josip-Bepo Benkovic, Herceg Novi, Yugoslavia, August 11-25, 1988. Museo de Arte Contemporaneo, Seville, Spain, October 3-21, 1988; Washington Irving Center, Madrid, Spain, November 3-22, 1988; Festival International du Dessin Contemporain Grand Palais, Paris, December 14-31, 1988. Exhibition catalogue, Introduction and text by Townsend Wolfe.

The John and Mable Ringling Museum of Art, Sarasota, Florida. *Contemporary Perspectives 1: Abstraction in Question*. January 20-April 2, 1989. Traveled to Center for Fine Arts, Miami, May 20-July 23. Exhibition catalogue, texts by Roberta Smith, Joan Simon, and Bruce W. Ferguson.

Kunsthalle, Recklinghausen, Germany. *Niemandsland*. January 29-March 5. Exhibition catalogue, text by Kornelia von Berswordt-Wallrabe.

Whitney Museum of American Art, New York. *1989 Biennial Exhibition*. April 27-July 9. Exhibition catalogue.

Fondation Daniel Templon Musée Temporaire. *Exposition Inaugurale*. July 11-September 10. Exhibition catalogue.

1990

Whitney Museum of American Art, New York. *The New Sculpture 1965-75: Between Geometry and Gesture*. March 2-June 3. Exhibition catalogue, texts by Richard Armstrong, John G. Hanhardt, Robert Pincus-Witten et al.

The Art Institute of Chicago. *Affinities and Intuitions: The Gerald S. Elliot Collection of Contemporary Art*. May 12-July 29.

Nippon Convention Center, Tokyo. *Pharmakon '90*. July 28-August 20. Exhibition catalogue, texts by Jan Avgikos, Achille Bonito Oliva and Motoaki Shinaohara.

Palace of Exhibitions, Budapest. *8th International Small Sculpture Triennial of Budapest*. September 27-October 8. Exhibition catalogue.

Hood Museum of Art, Dartmouth College, Hanover, New Hampshire. *Minimalism and Post-Minimalism: Drawing Distinctions*. October 27-December 16. Exhibition catalogue, text by James Cuno.

1991

Margo Leavin Gallery, Los Angeles. *20th Century Collage*. January 12-February 16. Traveled to: Centro Cultural Arte Contemporary, Mexico City, June 13-August 13; Musée d'Art Contemporain, Nice, September 27-November 11.

Fondation Daniel Templon, Musée Temporaire, Fréjus, France. *La Sculpture Contemporaine: après 1970*. July 4-September 29. Exhibition catalogue, Introduction by Caroline Smulders, texts by Carter Ratcliffe, Pierre Cabanne, Daniel Dobbels, Siegfried Gohr, and Demetrio Paparoni.

The Parrish Art Museum, Southampton, New York. *Minimalism and Post-Minimalism: Drawing Distinctions*. September 22-November 17.

1992

The Museum of Modern Art, New York. *Allegories of Modernism*. February 16-May 5.

San Jose Museum of Art, California. *Drawing Redux*. March 22-June 21. Exhibition catalogue, text by Phyllis Tuchman.

Stedelijk Museum, Amsterdam. *Century in Sculpture*. Summer 1992.

1993

Galerie Saqqârah, Gstaad, Switzerland. *From Rodin to Serra*. Exhibition catalogue, text by Georges Marci.

Weatherspoon Art Gallery, The University of North Carolina at Greensboro. *In Search of Form: Drawings by Fifteen Sculptors*. March 14-May 9.

Takashimaya, Tokyo. *Manhattan Breeze—Five Contemporary Artists*. April 22-27. Traveled to: Takashimaya, Osaka, April 29-May 4; Kyoto, May 13-18; and Yokohama, June 10-15. Exhibition catalogue, text by Tadao Ogura.

Le Domaine de Kerguehennec, Centre d'art, Locminé, France. *De la main à la tête, l'objet théorique*. May 1-September 19. Exhibition brochure.

45th Venice Biennale, Peggy Guggenheim Collection, Venice. *Drawing the Line Against AIDS*, exhibition in conjunction with *Art Against AIDS Venezia*. June 8-13. Exhibition catalogue.

The Utsukushi-ga-hara Open-Air Museum, Nagano-ken, Japan. *Fujisankei Biennale*. July 16-October 31.

IVAM Centre Del Darme (sponsored by IVAM Centre Julio Gonzalez). *Postminimal Sculptures at the Collection of IVAM*. September-December 1993.

1994

The Aldrich Museum of Contemporary Art, Ridgefield, Connecticut. *30 YEARS - Art in the Present Tense: The Aldrich's Curatorial History 1964-1994*. May 15-September 17.

Newport Harbor Art Museum, Newport Beach, California. *The Essential Gesture*. October 15-December 31. Exhibition catalogue, text by Bruce Guenther.

1995

The Museum of Modern Art, New York. *American Sculptors in the 1960s: Selected Drawings from the Collection*. February 16-June 13.

Lannan Foundation, Los Angeles. *FLOORED Sculpture from the Lannan Foundation Collection*. April 8-August 13.

The Aspen Art Museum, Colorado. *Contemporary Drawing: Exploring the Territory*. July 27-September 24; curated by Mark Rosenthal. Exhibition catalogue, text by Mark Rosenthal.

The Metropolitan Museum of Art, New York. *Sculptors' Drawings: 1945-90*. August 22-January 7, 1996.

Washington, D.C. *Twentieth Century American Sculpture at The White House, Exhibition III*. October 6-March 15, 1996. Curated by Alison de Lima Greene.

Fundacao Cultural de Curitiba, Curitiba, Brazil. *XI Mostra da Gravura Cidade de Curitiba/Mostra America (Brazil)*. October 23-December 23. Exhibition catalogue, text by Deborah Panek.

Tel Aviv Museum of Art. *A Passion for the New: New Art in Tel Aviv Collections*. October 30-January 27, 1996. Exhibition catalogue, text by Nehama Guralnik.

1996

Museum of Contemporary Art, San Diego. *Continuity and Contradiction*. March 10-August 31. Traveled to the Center for the Fine Arts, Miami Beach, December 19-February 23, 1997.

National Gallery of Art, Washington, D.C. *The Robert and Jane Meyerhoff Collection*. March 31-July 21. Exhibition catalogue.

National Gallery and Alexandros Soutzos Museum, Athens. *Art at the End of the 20th Century: Selections from the Whitney Museum of American Art*. June 10-September 30, 1996. Traveled as *Multiple Identity: Amerikanische Kunst 1975-1995 Aus Dem Whitney Museum of American Art* to Museu d'Art Contemporani, Barcelona, December 18-April 6, 1997; Kunstmuseum, Bonn, June-September, 1997.

The Museum of Modern Art, New York. *Thinking Print: Books to Billboards, 1980-95.* June 20-September 26. Exhibition catalogue, text by Deborah Wye.

Washington, D.C. *Twentieth Century American Sculpture at The White House. Exhibition V.* October 8-April 1997. Curated by Earl A. Powell III.

The Fine Arts Museums of San Francisco, California Palace of the Legion of Honor. *Masterworks of Modern Sculpture: The Nasher Collection.* October 1996-January 1997. Traveled as *A Century of Sculpture: The Nasher Collection* to Solomon R. Guggenheim Museum, New York, February-April 1997. Exhibition catalogue, Introduction by Carmen Giménez, interview with Raymond Nasher by Steven A. Nash, text by Michael Brenson.

1997

The Corcoran Gallery of Art, Washington D.C. *Proof Positive: 1957-1987.* February 15-June 30, 1997. Traveled to UCLA at the Armand Hammer Museum of Art and Cultural Center, Los Angeles, October 27, 1997-January 4, 1998; Sezon Museum of Art, Tokyo, February 27-April 6, 1998; and Kitakysyu Municipal Museum of Art, Kitakysyu City, Japan, June-July 1998. Exhibition catalogue.

Traveling exhibition organized and circulated by Independent Curators Incorporated, New York. *At the Threshold of the Visible: Minuscule and Small-Scale Art, 1964-1996.* Traveled to Herbert F. Johnson Museum of Art, Cornell University, Ithaca, August 30-October 26, 1997; Meyerhoff Galleries, Maryland Institute of Art, Baltimore, November 21-December 21, 1997; Art Gallery of Ontario, Toronto, Ontario, January 28-April 22, 1998; Art Gallery of Windsor, Windsor, Ontario, May-June, 1998; Virginia Beach Center for the Arts, Virginia Beach, June 26-August 23, 1998; Santa Monica Museum of Art, California, October-December 1998; Edmonton Art Gallery, Edmonton, Alberta, April 10-June 13, 1999. Exhibition catalogue, texts by Ralph Rugoff and Susan Stewart.

Addison Gallery of American Art, Phillips Academy, Andover, Massachusetts. *The Serial Attitude.* September 20-January 4, 1998. Traveled to the Wexner Center for the Arts, Ohio State University, Columbus, May 9-August 8, 1998.

Harvard University Art Museums, Cambridge, Massachusetts. *Drawing Is Another Kind of Language: Recent American Drawings from a New York Private Collection.* December 12-February 22, 1998. Travels to Kunstmuseum Winterthur, September 4-November 15, 1998; Kunst-Museum Ahlen, December 6, 1998-January 31, 1999; Akademie der Künste, Berlin, February 19-April 25, 1999; Fonds régional d'art contemporain de Picardie and Musée de Picardie, Amiens, May 21-August 15, 1999; The Parrish Art Museum, Southampton, New York, October 3-November 14, 1999. Exhibition catalogue.

1998

Walker Art Center, Minneapolis. *100 Years of Sculpture: From the Pedestal to the Pixel.* February 22-May 24, 1998.

Tate Gallery, London. *Contemporary Art: The Janet Wolfson de Botton Gift.* February 24-April 26, 1998. Exhibition catalogue.

Österreichisches Theater Museum, Vienna. *Der Sprechnende Körper.* March 26-July 5, 1998.

Orlando Museum of Art, Florida. *A Selection of Works from the Edward R. Broida Collection.* Spring 1998. Exhibition catalogue, essay by Sue Scott; interview with Edward Broida.

SELECTED ARTICLES AND REVIEWS

1969

Glueck, Grace. "Air, Hay and Money." *The New York Times*, May 25, 1969.

Schjeldahl, Peter. "To Experience Art as it is Evolving." *The New York Times*, December 28, 1969.

1970

Pincus-Witten, Robert. "Reviews: New York." *Artforum*, 8 (May 1970), pp. 74-81.

Ratcliff, Carter. "Reviews and Previews." *ARTnews*, 69 (May 1970), pp. 20-28.

1972

Borden, Lizzie. "Reviews: New York." *Artforum*, 10 (April 1972), pp. 81-89.

1973

Crimp, Douglas. "Reviews and Previews." *ARTnews*, 72 (Summer 1973), pp. 100-101.

Smith, Roberta. "Reviews: Joel Shapiro." *Artforum*, 11 (June 1973), pp. 85-88.

1974

Lubell, Ellen. "Arts Reviews: Joel Shapiro." *Arts Magazine*, 48 (April 1974), pp. 67-69.

1975

Bear, Liza. "Joel Shapiro Torquing: A Dialogue with Liza Bear." *Avalanche*, 11 (Summer 1975), pp. 15-19.

Kramer, Hilton. "Art: Joel Shapiro." *The New York Times*, November 1, 1975.

Lubell, Ellen. "Arts Review: Joel Shapiro." *Arts Magazine*, 50 (December 1975), p. 20.

1976

Ratcliff, Carter. "Notes on Small Sculpture." *Artforum*, 14 (April 1976), pp. 35-42.

Schwartz, Sanford. "Little Big Sculpture." *Art in America*, 64 (March/April 1976), pp. 53-55.

Smith, Roberta. "Review: New York-Joel Shapiro." *Artforum*, 14 (February 1976), pp. 64-65.

1977

Bannon, Anthony. "Sculpture by Shapiro Demands Awareness." *Buffalo Evening News*, March 29, 1977.

Clark, Susan. "Shapiro's 'Aggressive' Geometry Shapes Space into Solid Forms." *Buffalo Evening News*, March 25, 1977.

Hess, Thomas B. "Art: Ceremonies of Measurement." *New York magazine*, 10 (March 21, 1977), pp. 60-62.

Masheck, Joseph. "Cruciformality." *Artforum*, 15 (Summer 1977), pp. 56-63.

Smith, Roberta. "The 1970s at the Whitney." *Art in America*, 65 (May/June 1977), pp. 91-93.

1978

Field, Marc. "On Joel Shapiro's Sculptures and Drawings." *Artforum*, 16 (Summer 1978), pp. 31-37.

Hess, Thomas B. "Where Have All the ISMS Gone?" *New York magazine*, 11 (February 13, 1978), pp. 69-79.

Pincus-Witten, Robert. "Strategies Worth Pondering: Bochner, Shapiro, Reise, LeWitt." *Arts Magazine*, 52 (April 1978), pp. 142-145.

Ratcliff, Carter. "Joel Shapiro's Drawings." *The Print Collector's Newsletter*, 9 (March/April 1978), pp. 1-4.

1979

Coplans, John. "Joel Shapiro: An Interview." *Dialogue*, I (January/February 1979), pp. 7-9.

Lecombre, Sylvain. "Joel Shapiro, Couper l'Espace." *Art Press International*, (July/August 1979), p. 41.

Lubell, Ellen. "Art: Joel Shapiro." *Soho Weekly News*, May 10, 1979, p. 46.

Schjeldahl, Peter. "Reviews: New York-Joel Shapiro." *Artforum*, 17 (Summer 1979), pp. 63-65.

1980

Hess, Elizabeth. "Art: Figuratively Speaking." *The Village Voice*, 25 (December 10, 1980), p. 105.

Russell, John. "Art: Joel Shapiro." *The New York Times*, December 12, 1980.

Sozanski, Edward. "Shapiro's Sculpture is Perceptual Experience." *The Providence Sunday Journal*, November 30, 1980.

Welch, Douglas. "Reviews: Joel Shapiro." *Arts Magazine*, 55 (November 1980), p. 35.

1981

Artner, Alan. "Large or Small, Shapiro Sculptures Scaled to Please." *Chicago Tribune*, November 29, 1981.

Payant, René. "Les Formes Complexes de Joel Shapiro." *Art Press*, 46 (March 1981), p. 23.

Phillips, Deborah C. "Reviews: Joel Shapiro." *Arts Magazine*, 55 (January 1981), pp. 29-30.

Schall, Jan. "Visiting Artist: Joel Shapiro." *Southeast Art Papers*, (March/April 1981), p. 17.

Stearns, Robert. "Joel Shapiro." *Dialogues*, (September/October 1981), pp. 30-31.

1982

Baker, Kenneth. "Joel Shapiro."*Christian Science Monitor*, September 8, 1982.

Jordy, William H. "The Sculpture of Joel Shapiro." *The New Criterion*, 1 (December 1982), p. 54.

Knight, Christopher. "Joel Shapiro's Work Tugs at Our Heartstrings." *Los Angeles Herald Examiner*, November 7, 1982.

Phillips, Deborah C. "Joel Shapiro." *ARTnews*, 81 (May 1982), pp. 162-163.

Russell, John. "Drawings by Joel Shapiro." *The New York Times*, January 22, 1982.

Russell, John. "Sculpture: Joel Shapiro in Whitney Exhibition." *The New York Times*, October 22, 1982.

Tomkins, Calvin. "Looking For the Zeitgeist." *New Yorker*, 58 (December 6, 1982), pp. 150-153.

1983

Damsker, Matt. "Sculptor's Forms Question Nature of Sculpture." *Los Angeles Times*, December 9, 1983.

Kidder, Gayle. "House is not a home to Joel Shapiro." *The San Diego Union*, December 2, 1983.

Knight, Christopher. "Joel Shapiro is a master of 'monumental intimacy'." *Los Angeles Herald Examiner*, December 11, 1983.

Kuspit, Donald. "Manifest Densities." *Art in America,* 71 (May 1983), pp. 148-152.

Kutner, Janet. "Explorations of Space, Shapiro's Sculptures Offer Eccentric Points of View." *Dallas Morning News*, March 14, 1983.

Shapiro, Michael. "Four Sculptors on Bronze Casting: Nancy Graves, Bryan Hunt, Joel Shapiro, Herk Van Tongeren." *Arts Magazine,* 58 (December 1983), pp. 111-117.

1984

Baker, Kenneth. "Artist's Dialogue: The Art of Joel Shapiro." *Architectural Digest*, 41 (June 1984), pp. 170-177.

Berger, Maurice. "Joel Shapiro: War Games." *Re-Dact: An Anthology of Art Criticism*, 1, (1984), pp. 16-21.

Brenson, Michael. "A Living Artists Show at the Modern Museum." *The New York Times*, April 21, 1984.

Pincus, Robert L. "A Transformer of Minimalism." *Los Angeles Times*, November 5, 1984.

Smith, Roberta. "Exercises for the Figure." *The Village Voice*, November 20, 1984.

1985

Cooke, Lynne. "Exhibition Reviews: Joel Shapiro, Sculptures and Drawings at Knoedler, London."*Burlington magazine,* 127 (September 1985), pp. 635-636.

Gibson, Eric. "The Minimal and the Magical." *The New Criterion,* 3 (January 1985), pp. 42-44.

Gibson, Eric. "Thinking About the Seventies." *The New Criterion,* (May 1985), pp. 45-48.

Ringnalda, Mariana. "Joel Shapiro-Stedelijk Museum." *Art Press*, 98 (1985), p. 62.

Saunders, Wade. "Talking Objects: Interviews with Ten Younger Sculptors." *Art in America*, 73 (November 1985), pp. 110-137.

Zimmer, William. "The Big and Little of Sculpture." *The New York Times*, October 13, 1985.

1986

"Album: Joel Shapiro." *Arts Magazine*, 61 (November 1986), pp. 114-115.

Brenson, Michael. "Joel Shapiro." *The New York Times*, November 14, 1986.

Cooke, Lynne. "Joel Shapiro at the Stedelijk Museum." *Artscribe*, (June/July 1986), pp. 83-84.

Dagen, Philippe. "Joel Shapiro: exercises de sculpture moderns." *Art Press*, 109 (December 1986), pp. 38-40.

Sischy, Ingrid. "On Location: Joel Shapiro." *Artforum*, 25 (November 1986), pp. 4-5.

Tuchman, Phyllis. "Shapiro: Redirecting Sculpture's Shapes." *Newsday*, November 28, 1986.

1987

Baker, Kenneth. "Shapiro Has it Figured Out." *San Francisco Chronicle*, October 21, 1987.

Bass, Ruth. "Minimalism Made Human." *ARTnews*, 86 (March 1987) pp. 94-101.

Brenson, Michael. "Images That Express Human Emotions." *The New York Times*, July 26, 1987.

Princenthal, Nancy. "Joel Shapiro at Paula Cooper." *Art in America*, 75 (February 1987), pp. 141-142.

Rubinstein, Meyer R. and Daniel Weiner. "Joel Shapiro." *Arts Magazine*, 61 (March 1987), p. 97.

1988

Bass, Ruth. "Joel Shapiro." *ARTnews*, 87 (Summer 1988), pp. 171-172.

Bouisset, Maiten. "Constructions de Joel Shapiro." *Beaux Arts*, 59 (September 1988), p. 94.

Dagen, Philippe. "Constructions, Reconstructions." *Le Monde*, September 14, 1988.

Greenberg, Jeanne. "Dialogue With Joel Shapiro." *Splash Magazine*, Winter 1988.

Johnson, Ken. "Joel Shapiro at Paula Cooper." *Art in America*, 76 (July 1988), p. 133.

1989

Baker, Kenneth. "Joel Shapiro's Sculptures of the 80's." *Artforum*, 27 (February 1989), pp. 102-106.

Brenson, Michael. "A Sculptor Who Rejects Nothing." *The New York Times*, May 21, 1989.

Greenberg, Jeanne. "Dialogue with Joel Shapiro." *Splash Magazine*, (Winter 1989), pp. 12-15.

Kent, Sarah. "Joel Shapiro." *Time Out*, October 25, 1989.

Marcus, Liz. "Joel Shapiro." *Sculpture*, (September-October 1989), pp. 83-84.

Princenthal, Nancy. "Against the Grain: Joel Shapiro's Prints." *The Print Collector's Newsletter*, 20 (September-October 1989), pp. 121-124.

1990

Brenson, Michael. "Joel Shapiro." *The New York Times*, November 23, 1990.

Danto, Arthur C. "Postminimalist Sculpture." *The Nation*, 250 (May 14, 1990), pp. 680-684.

Gibson, Eric. "Sculptor Joel Shapiro: from abstraction to representation," *Washington Times*, August 29, 1990.

Giuliano, Mike. "BMA exhibit examines sculptor's human allusions." *The Evening Sun*, August 23, 1990.

Hughes, Robert. "Sculpture of the Absurd." *Time*, 136 (October 1, 1990), pp. 100-102.

"Joel Shapiro: Tracing the Figure." *The Wall Street Journal*, August 21, 1990.

Princenthal, Nancy. "The New Scultpure 1965-1975: Between Geometry and Gesture." *Sculpture*, 9 (July/August, 1990), pp. 40-45.

Smith, Roberta. "Sculpture at the Whitney: The Radical Years." *The New York Times*, March 9, 1990.

1991

Braff, Phyllis. "Defining the Minimalist Directions From the 60's to the Present." *The New York Times*, November 10, 1991.

Cotter, Holland. "Joel Shapiro at Paula Cooper." *Art in America*, 79 (July 1991), p. 125.

Dobbels, Daniel. "Joel Shapiro au bord de la chute." *Libération*, July 29, 1991.

Faust, Gretchen. "Joel Shapiro." *Arts Magazine*, 65 (February 1991), p. 102.

Hummeltenberg, Hanna. "Künstler Kritisches Lexikon der Gegenwartskunst: Joel Shapiro." Issue 16, Munich, 1991.

Perl, Jed. "Mostly Minimal: Joel Shapiro." *Art & Antiques*, 8 (February 1991), p. 91.

Smulders, Caroline. "Joel Shapiro, L'Espace Métamorphique." *Art Press*, 159 (June 1991), p. 23-27.

1992

Bigham, Elizabeth French. "Joel Shapiro." *Tema Celeste*, 36 (Summer 1992), pp. 82-83.

Kertess, Klaus. "Cast in Bronze." *Elle Decor* (April/May 1992), pp. 17-21.

1993

Cotter, Holland. "Art in Review: Joel Shapiro." *The New York Times*, May 21, 1993.

Gill, Brendan. "The Holocaust Museum: An Unquiet Sanctuary." *New Yorker*, 59 (April 19, 1993).

Kuspit, Donald. "Joel Shapiro-Pace Gallery." *Artforum*, 32 (November 1993), p. 103.

MacAdam, Barbara. "Joel Shapiro-Pace." *ARTnews*, 92 (October 1993), p. 160.

Princenthal, Nancy. "Joel Shapiro at Pace." *Art in America*, 81 (September 1993), p. 109.

1994

Goodrow, Gérard A. "Joel Shapiro-Karsten Greve." *ARTnews*, 93 (February 1994), p. 150.

Thorson, Alice. "Artist Now at Work on Airport Sculpture." *Kansas City Star*, April 10, 1994.

1995

Landi, Ann. "Kiss & Tell." *ARTnews*, 94 (February 1995), pp. 116-119.

Smith, Roberta. "Joel Shapiro Looks Back, Differently." *The New York Times*, March 31, 1995.

Suchère, Eric. "Joel Shapiro: Galerie Karsten Greve" *Art Press*. 204 (July/August 1995), p. 81.

1996

Baker, Kenneth. "Minimalism and More by Shapiro." *San Francisco Chronicle*, April 2, 1996.

Cuno, James. "Joel Shapiro on his Recent Prints: An Interview." *The Print Collector's Newsletter,* 27 (May-June 1996), pp. 46-50.

Gear, Josephine. "The Old is New Again: Joel Shapiro at PaceWildenstein." *Review Art*, 2 (October 15, 1996).

MacAdam, Barbara A. "Joel Shapiro: Punch and Judy." *ARTnews*, 95 (January 1996), p. 83.

Pagel, David. "Joel Shapiro's Sculptures Embody Joy of Movement." *Los Angeles Times*, March 28, 1996.

Thorson, Alice. "Something Special On The Ground." *The Kansas City Star,* May 20, 1996.

1997

Cotter, Holland. "A Show That Could Travel In Just a Carry-On Bag." *The New York Times*, December 14, 1997.

Meier, Phillipp. "Tanzende Skulpturen - Joel Shapiro in der Galerie Jamileh Weber." *Neue Zürcher Zeitung* (Zürich), September 23, 1997.

Temin, Christine. "Joel Shapiro's floor show." *The Boston Globe*, October 18, 1997.

1998

"Abstraktion und Bildhaftigkeit." *Hamburger Abendblatt*, January 30, 1998, p. 6.

"Joel Shapiros Kampf mit der Schwerkraft." *Welt am Sonntag* (Hamburg). February 1, 1998, p. 80.

COMMISSIONS AND PUBLICLY SITED WORKS

1983-84 Cigna Corporation
Philadelphia, Pennsylvania
Architect: Kohn, Pederson, and Fox

1988 Fukuoka Sogo Bank
Fukuoka, Japan
Architect: Arata Isozaki

1988-89 Creative Artists Agency
Los Angeles, California
Architect: I.M. Pei and Partners

1988-89 Kawamura Memorial Museum of Art
Chiba, Japan
Architect: I. Ebihara

1988-90 Government Service Administration
Los Angeles, California
Architect: Ellerbe Becket

1989-90 Hood Museum of Art
Dartmouth College
Hanover, New Hampshire
Architect: Centerbrook, Charles Moore

1993 United States Holocaust Memorial Museum
Washington, D.C.
Architect: James Ingo Freed; Pei, Cobb, Freed &
Partners

1994-95 Sony Plaza
New York City
Architect: Philip Johnson, Gwathmey Siegel and
Associates Architects

1994-95 Tishman Speyer Berlin GmbH & Co.
Friedrichstadt Passagen
Berlin, Germany
Architect: O.M. Ungers

1994-96 Kansas City International Airport
Kansas City, Missouri

PRIVATE COMMISSIONS

1982 Leede Exploration
Englewood, Colorado

1983 Douglas Cramer Foundation
Los Angeles, California

1990-95 Designed the National Book Award

1995 Designed the PEN/Newman's Own First
Amendment Award

PUBLIC COLLECTIONS

The Ackland Art Museum, Chapel Hill, North Carolina

Addison Gallery of American Art, Phillips Academy, Andover, Massachusetts

Albright-Knox Art Gallery, Buffalo, New York

Art Gallery of Ontario, Toronto, Canada

The Art Institute of Chicago, Chicago, Illinois

Art Museum of South Texas, Corpus Christi, Texas

The Baltimore Museum of Art, Baltimore, Maryland

British Museum, London, England

The Brooklyn Museum, Brooklyn, New York

Cincinnati Art Museum, Cincinnati, Ohio

The Cleveland Museum of Art, Cleveland, Ohio

Colby College Museum of Art, Waterville, Maine

The Corcoran Gallery of Art, Washington, D.C.

Dallas Museum of Art, Dallas, Texas

The Denver Art Museum, Denver, Colorado

Des Moines Art Center, Des Moines, Iowa

The Detroit Institute of Arts, Detroit, Michigan

The Douglas S. Cramer Foundation, Los Angeles, California

Eli Broad Foundation, Los Angeles, California

Fogg Art Museum, Harvard University, Cambridge, Massachusetts

Grand Rapids Art Museum, Grand Rapids, Michigan

Hakone Open-Air Museum, Hakone-machi, Japan

Hall Family Foundation on permanent loan to The Nelson-Atkins Museum of Art, Kansas City, Missouri

The High Museum of Art, Atlanta, Georgia

Hirshhorn Museum and Sculpture Garden, Smithsonian Institution, Washington, D.C.

Ho-Am Art Museum, Seoul, Korea

Hood Museum of Art, Dartmouth College, Hanover, New Hampshire

Israel Musem, Jerusalem, Israel

IVAM Centre Julio González, Valencia, Spain

The John and Mable Ringling Museum of Art, Sarasota, Florida

Kunsthaus Zürich, Zürich, Switzerland

Lannan Foundation, Los Angeles, California

Los Angeles County Museum of Art, Los Angeles, California

Louisiana Museum for Moderne Kunst, Humlebaek, Denmark

The Menil Collection, Houston, Texas

The Metropolitan Museum of Art, New York, New York

Milwaukee Art Museum, Milwaukee, Wisconsin

Modern Art Museum of Fort Worth, Fort Worth, Texas

Moderna Museet, Stockholm, Sweden

Musee national d'art moderne, Centre Georges Pompidou, Paris, France

Museum of Contemporary Art, Chicago, Illinois

Museum of Contemporary Art, Los Angeles, California

Museum of Contemporary Art, San Diego, California

Museum of Fine Arts, Boston, Massachusetts

The Museum of Fine Arts, Houston, Texas

Museum of Modern Art, Friuli, Italy

The Museum of Modern Art, New York, New York

The Nasher Collection, Dallas, Texas

National Gallery of Art, Washington, D.C.

National Gallery of Australia, Canberra, Australia

The Newark Museum, Newark, New Jersey

North Carolina Museum of Art, Raleigh, North Carolina

The Parrish Art Museum, Southampton, New York

Philadelphia Museum of Art, Philadelphia, Pennsylvania

The Picker Art Gallery, Colgate University, Hamilton, New York

Rose Art Museum, Brandeis University, Waltham, Massachusetts

The Saint Louis Art Museum, Saint Louis, Missouri

Sheldon Memorial Art Gallery and Sculpture Garden, University of Nebraska, Lincoln, Nebraska

Stedelijk Museum, Amsterdam, The Netherlands

Tate Gallery, London, England

Tel Aviv Museum of Art, Tel Aviv, Israel

The Toledo Museum of Art, Toledo, Ohio

University of Massachusetts, Amherst, Massachusetts

Walker Art Center, Minneapolis, Minnesota

Weatherspoon Art Gallery, University of North Carolina, Greensboro, North Carolina

Wexner Center for the Arts, Ohio State University, Columbus, Ohio

Whitney Museum of American Art, New York, New York

Photograph Credits:

All color plates by Greg Heins
All black and white views by Jock Reynolds,
except page 16 by Leslie Maloney